Contents at a Glance

Table of Contents

About the Author

Peter Bauer is perhaps best known as the help desk director for the National Association of Photoshop Professionals (NAPP). He is also the author of a number of books on computer graphics and digital photography, including *Photoshop CS2 For Dummies* (Wiley). Pete writes regularly for *Photoshop User* and *Layers* magazines and the graphics portal PlanetPhotoshop. com. He's part of the Photoshop World Instructor Dream Team. Pete and his wife, Professor Mary Ellen O'Connell (who holds the Robert and Marion Short Chair in Law at the Notre Dame Law School), live in a historic area of South Bend, Indiana. (All images in this book are Copyright 2005 by Peter Bauer.)

Dedication

This book is dedicated to the wonderful folks who keep me on my toes and at the top of my game: to the membership of NAPP, who send me more than 20,000 email questions about digital photography and imaging each year.

We Want to Hear from You!

As the reader of this book, *you* are our most important critic and commentator. We value your opinion and want to know what we're doing right, what we could do better, what areas you'd like to see us publish in, and any other words of wisdom you're willing to pass our way.

As an associate publisher for Sams Publishing, I welcome your comments. You can email or write me directly to let me know what you did or didn't like about this book—as well as what we can do to make our books better.

Please note that I cannot help you with technical problems related to the topic of this book. We do have a User Services group, however, where I will forward specific technical questions related to the book.

When you write, please be sure to include this book's title and author as well as your name, email address, and phone number. I will carefully review your comments and share them with the author and editors who worked on the book.

Email: feedback@samspublishing.com

Mail: Paul Boger
 Publisher
 Sams Publishing
 800 East 96th Street
 Indianapolis, IN 46240 USA

For more information about this book or another Sams Publishing title, visit our website at www.samspublishing.com. Type the ISBN (excluding hyphens) or the title of a book in the Search field to find the page you're looking for.

Welcome to *Create Your Own Digital Photography*

You've never taken a class in photography—and perhaps have never even taken a picture before. But you have a digital camera now—perhaps it was a gift, perhaps you purchased it yourself—and you want to use it properly. You may want to take photos of family and friends, probably vacation shots, maybe even some special "artsy" photos. Maybe you know your way around a camera, and perhaps you're only comfortable with the Auto mode. You might be intimately familiar with your camera's user guide, or you might have found that slim booklet either daunting or completely lacking. (Various camera manufacturers pay differing amounts of attention to their documentation.) This book is for *you*.

This book is *not* for professional studio photographers, fine-art photographers, or experienced commercial artists. It's for people who haven't been working in the field, who don't (yet?) get paid for their photos.

I suspect that this book will be given as a gift as often as it's purchased for personal use. It's great for folks just starting out with digital cameras—and perhaps should be wrapped up with the camera when given to a beginner.

The Wide World of Digital Cameras

Digital cameras come in a wide range of capabilities—and prices. Odds are, you already own a digital camera. But what else is out there? How does your camera stack up? The market changes so fast that between the time I type these words and the time you read them, dozens (or even hundreds) of new digital cameras will have been released. But that doesn't mean we can't generalize, does it? Take a look at this figure, which shows a range of digital cameras:

Each camera is shown with a full-size print at 300 ppi (pixels per inch), the optimal image resolution for most inkjet printers.

On the left is a tiny little freebie camera that I received some years ago with an order of computer equipment. On the right is an affordable "prosumer" camera, the Canon 20D. It is a digital SLR camera, and you can use with it a variety of interchangeable lenses, as well as detachable flash units and other accessories. In between are typical cameras with which most folks take digital photos, and *those* cameras are the focus of this book.

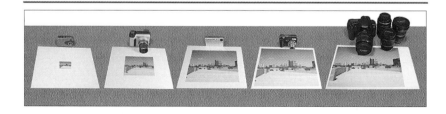

NOTE

Digital cameras can cost as little as, well, nothing, and as much as tens of thousands of dollars. In this book I work with (and assume you work with) cameras that range from about $100 to about $500. These cameras generally have a single fixed lens (with or without zoom capability) and record somewhere between 3 megapixels and 7 megapixels. The discussion and projects you find in this book are not designed for tiny little digital cameras that capture less that 2 megapixels, nor for professional digital SLR (single lens reflex) cameras with interchangeable lenses.

When shopping for a camera (and who won't be looking for a better camera *someday*?), there are two concepts you should keep in mind:

▶ **More megapixels is not always better**—A *lot* of factors determine the quality of your digital photos. The computer chip that records the data (CCD or CMOS), the lens, and even the software embedded in the camera all have an impact on the quality of your images. But, generally speaking, 5 megapixels will give you a better image than 3 megapixels, and 7 megapixels will give you a better enlargement than 5 megapixels. If you can, see some sample shots from cameras that seem to fit your needs.

▶ **Look for optical zoom,** *not* **digital zoom**—Optical zoom is like looking through a telescope to get a closer shot. This is a great thing; it makes your camera more versatile and presents you with a number of creative possibilities. On the other hand, you should avoid digital zoom

if possible. It simulates zooming by enlarging pixels (which can degrade the quality of your images and make details fuzzy).

You might also want to consider factors such as the type of battery (rechargeable or disposable) and whether the camera can be hooked directly to a photo printer you already own.

How You Should Read This Book

At least for the first reading, you should start at the front and work your way to the back. Later, after you've worked through the book the first time, you can most certainly reread specific sections at your leisure. If you've already read your camera's user guide, you might want to reread it after you read Project 1, "Capture Your Life Visually." (It may finally make some sense.) If you haven't yet read the user guide that came with your camera, please do so after reading Project 1.

What's on the Book's CD

This book's CD includes some software: Picasa (a free program from Google.com for organizing your photos) and a demo version of Adobe Photoshop Elements (a 30-day trial version of a very powerful image-editing program). You'll also find a number of sample images to use with the various exercises in this book, as well as some templates for creating your own greeting cards and calendars. (Please keep in mind that the images on the CD are for use only with the exercises in this book and cannot be used for commercial purposes.)

CHAPTER 1

Capture Your Life Visually

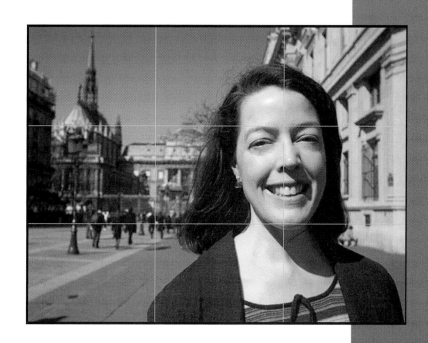

There are two keys to capturing great photos with a digital camera: using the correct settings and *composition* (that is, framing the subject in the viewfinder or LCD display before clicking the shutter). In this project, I'll show you how to use the various settings on typical digital cameras, share some tricks for handling difficult situations, and offer some tips on creative composition. Then it's time for a mini "photo safari," as you practice shooting while capturing images to use throughout the rest of this book. You'll also see how to avoid some of the most common photo problems, such as *red eye* (that undesirable red reflection in someone's eyes), underexposed subjects, and shadows behind group photos.

Getting to Know Your Camera

Using the correct camera settings for the situation ensures that you'll get a proper *exposure*— that is, that the photo will realistically represent the scene as you saw it. The highlights in the image will be white, the shadows will be black, and the colors will look natural. This is often as simple as selecting Auto or Automatic and letting the camera use its own best judgment. But understanding and using the various options on your camera enables you to perfect the exposure in certain circumstances, such as difficult lighting and extreme close-ups.

Taking a Digital Picture: The Basics

You'll want to know how to turn the camera on and off, how to aim (through a viewfinder

or by using an LCD display), how to zoom in and out (if your camera offers that option), and how to focus and shoot. Generally speaking, the basic procedure is this:

1. **Prepare the camera and turn it on**— Before using the camera for the first time, you need to fully charge the battery and insert the camera's recordable media. Figure 1.1 shows some of the variety of on/off switches and media you might find.

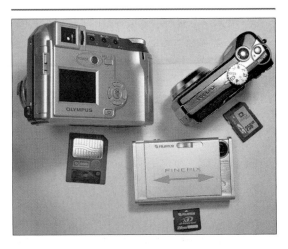

FIGURE 1.1

Different cameras have on/off buttons in different locations—and some you turn on by sliding a cover to expose the lens.

NOTE

Throughout this book I use the term *card* to refer to a digital camera's removable storage media. Consider the generic term to include CompactFlash cards, SmartMedia memory cards, Secure Digital (SD) cards, xD-Picture cards, memory sticks, mini-drives, and all other removable storage for digital cameras.

2. **Aim the camera and (optionally) zoom**—With some cameras, you hold the camera to your face and look through a viewfinder to see what will be included in the image. Other cameras have an LCD screen that you look at to aim the camera. Some have both.

TIP

If your camera has both a viewfinder and an LCD screen, learn to use both. The LCD screen is generally better in low-light situations and often shows the composition more accurately, but you'll need the viewfinder in bright environments. Remember, too, that you can turn off the LCD display to save your battery strength.

3. **Press the shutter release button halfway down to focus**—It can take some practice to find the halfway point where the camera engages its auto focus but doesn't yet take the picture. Fortunately, it costs just about nothing to accidentally take a shot (or several) while learning how far is "halfway down."

4. **Take the shot**—When the camera is focused and you're happy with what you see in the viewfinder or on the LCD display, press the button the rest of the way down to capture the shot. Press gently so that you don't move the camera while taking the picture.

5. **Review the shot**—Press the button or select the menu item that looks like the Play button on a DVD player or VCR—a triangle pointing to the right, usually within a box. That's the Playback button, and it displays the last shot on the camera's LCD screen.

Your camera probably also offers the possibility of scrolling back and forth to view all the images on the camera's media—and deleting shots you don't like to make more space on the card.

6. **(Later) Print or download the image**—Project 2 covers the topics of downloading your images to your computer and printing.

NOTE

Throughout this book, you'll see pictures of cameras without wrist straps attached. That's strictly for aesthetic purposes. When you see something like the image on the left, imagine that you're actually seeing something like the image on the right.

I strongly urge you to *always* use your camera's wrist strap or neck strap. Think of it as a seatbelt for your digital treasure-maker.

Exploring the Shooting Mode Options

Your camera likely has a number of preset *modes* that help the camera capture photos properly under specific circumstances. Take a

look at the rather similar icons shown in Figure 1.2.

> **TIP**
>
> The best place to start learning about your camera's features is, of course, its user guide. But if you haven't read it yet, read this project first to give yourself some background information. If you have already read the user guide, and it didn't make much sense to you, read it again after finishing this project.

Here's a quick look at when to use each of the most common shooting modes and what they do for you:

▸ **Close Up**—Close Up mode is typically represented by one or two stylized tulips (or

so the flowers would appear), and you use it for photos of small objects, near to the lens. In addition, you can use Close Up mode for jewelry, bugs, and other small objects. Some cameras use the term *Macro* for this setting.

▸ **Landscape**—Turn the dial to landscape (or select Landscape from the menu) when shooting at a distance. The typical icon shows mountains (see Figure 1.3), but you'll also use Landscape for city shots. In this mode, you get great focus on distant objects.

> **TIP**
>
> Use Landscape mode for portraits of people when you want the background to be in sharp focus, such as when taking a picture of someone in front of a recognizable landmark.

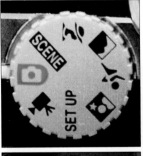
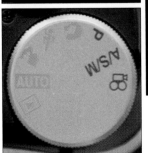

FIGURE 1.2

You may see variations, but the symbols for digital camera modes are pretty much standardized.

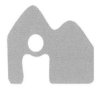 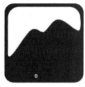

FIGURE 1.3
A mountain icon tells you that you're in Landscape mode.

FIGURE 1.4
Night/Night Portrait mode fires the flash but leaves the camera's shutter open a moment longer so that the background is also visible.

▶ **Natural Light/Flash Off**—Generally represented by the letter *N* or the words *Flash Off*, this mode prevents the flash from firing. You might use Natural Light/Flash Off in a church or museum, when taking a picture of a sleeping child or animal, or when shooting a picture of candles. You should place the camera on a solid surface or hold it *very* still when shooting in this mode; this mode's slower shutter speed means you'll get a blurry image if the camera moves. If your camera doesn't offer Natural Light mode, you turn off the flash manually (as explained later in this project).

▶ **Night/Night Portrait**—You use this mode when taking pictures at night of something close (such as a person) when you also want the background visible. The icon typically shows a person and a star or moon, or a moon/star combination (see Figure 1.4). The flash will fire to illuminate the subject, but the camera's shutter stays open a moment longer so that the dark background can also be seen. You should use a tripod, rest the camera on a solid surface, or stay very still when shooting in this mode—and make sure to tell the subject to stay still even after the flash fires!

▶ **Portrait**—The icon for Portrait mode is generally a stylized profile of a woman (see Figure 1.5 for examples). You use this mode when taking photos of a person from perhaps midchest and up, especially against busy backgrounds that are some distance away (more than perhaps 4 feet). The background will be slightly blurred, which lets the subject stand out a bit better.

FIGURE 1.5
A camera's Portrait mode is generally represented by a woman in profile (with or without a hat) .

MOVIE MODE

Many digital cameras are capable of taking short bits of video (with or without sound). The videos are typically 640 pixels wide by 480 pixels tall or 320 pixels wide by 240 pixels tall, and the quality is generally pretty good (for a non-camcorder, of course). How large is 640×480? When played back on a computer monitor set to a screen resolution of 1024×768 pixels, you have a pretty good view of the action:

Typically, a digital camera captures video in the QuickTime .mov file format. To view QuickTime movies, you need the free (yes, absolutely *free*!) QuickTime Player software from www.apple.com/quicktime.

Some cameras limit the length of each segment to perhaps 15 seconds or so, while others let you film until your recordable media is full. Some cameras record 30 fps (frames per second), some record at 15 fps, and some give you a choice. The images are small in dimension but large in file size. By capturing movies at 640×480 and 30 fps, you can expect to record a little over 3 minutes on a 256MB card and just under 15 minutes on a 1GB card. Cut your frame rate to 15 fps, and you can just about double

TIP

If your subject wears eyeglasses, you'll want to pose her or him looking at an angle to the camera so that your flash doesn't reflect directly off the lenses. Looking through the viewfinder or at the LCD, be aware of reflections on the lenses from existing light sources. Make sure to take an extra shot with the glasses off, too.

▶ **Sports**—When the subject is in motion and you don't want a blurry photo, you should opt for Sports mode. When at a game or on the street, this is the mode for fast shutter speeds. The Sports mode seems always to be represented by a running man icon. (It may sometimes appear that the man is falling rather than running, as you see in Figure 1.6, but the mode is called *Sports*, not *Accident*.)

FIGURE 1.6

Sports mode, used for fast shutter speeds that catch action unblurred, is represented by a running man.

TIP

Remember that you can change the resolution of your monitor when it's time to play a movie. If you typically work with your monitor set to perhaps 1280×1024 pixels, you can temporarily change that to 800×600 pixels, watch the movie, and then change the resolution back. (You'll generally get a better picture by using this method than if you simply enlarge the playback size on a monitor set to high resolution.) You change your monitor resolution by going to the Start menu and selecting Control Panel. Then you double-click Display and click the Settings tab to make the change. You use the same procedure to return your monitor to your working resolution after viewing the movie.

those estimates. Shooting at 320×240 pixels lets you capture a whole lot more time, but the images are *tiny*. If your monitor is set to 1280×1024 pixels and you're viewing a movie at 320×280 pixels, it's sort of like being in the third balcony at the theater.

Here are some tips for recording video with your digital camera (but remember to check your user guide for camera-specific information):

▶ Zoom first—Most digital cameras disable the optical zoom while recording video. And digital zoom generally isn't available at all when capturing a movie.

▶ Use a tripod (when possible)—If you can, use a tripod with the head loose enough to permit swiveling as you record. The tripod not only keeps the camera from jerking around, it helps maintain the detail in the video.

▶ Check your card and battery—The card should be empty and the battery full—not the other way around!

continues

▶ **Pan slowly**—When moving the camera side-to-side or up-and-down, move slowly and smoothly—especially when recording at 15 fps.

▶ **Shhh!**—If your camera records audio (and you're recording audio), be very quiet while shooting. You might want to turn off any audio signals that the camera uses to avoid unwanted beeps and boops in your movie.

Of course the basic footage you capture with a digital camera probably isn't going to win many awards. You'll probably want to spice it up a little, perhaps with some transitions between scenes, maybe some titles, perhaps a special effect or two. You can purchase highly capable software for digital video editing, such as Adobe Premiere Elements, for under $100.

For a look at what you might be able to do with video from your digital camera and some affordable editing software, take a look at the short video SledDogs.mov on this book's CD. (You'll need the free QuickTime software for playback.) The video was captured in 15-second clips with an Olympus C-series digital camera.

Your Camera's Flash Modes

Your camera's built-in flash capability can help you capture great images in a variety of lighting situations. Used in conjunction with the various camera modes (explained earlier in this project), flash options can work wonders! But what do those symbols mean and when should you use each? Examples of typical flash symbols are shown in Figure 1.7.

Here's what you need to know about your camera's flash modes:

▶ **Auto Flash**—With the flash set to Auto, the camera determines whether the flash is necessary and, when necessary, sets and fires the flash. This is the all-purpose flash settings, and you should consider it to be your default setting.

▶ **Red Eye Reduction**—When taking reasonably close pictures of people (within perhaps 10 feet) facing the camera, Red Eye Reduction is the best choice. A low-power flash fires a moment before the picture is taken, and then the regular flash fires with the shutter. The first flash constricts the pupils in your subject's eyes, preventing a red reflection off the back of the eye. (Make sure to warn your subjects that they need to hold still for a few seconds and that they should expect two flashes of light.) Figure 1.8 shows a close-up comparison of a red eye problem and the result when shooting with the Red Eye Reduction mode on.

▶ **Flash Off**—If you're taking photos inside a museum or church, or during a ceremony, turning off the flash is the considerate (and sometimes required) thing to do. Make sure to hold the camera as still as possible when shooting indoors without the flash so that your images don't blur. You'll also want to

FIGURE 1.7

From the left: Auto Flash, Red Eye Reduction, Flash Off, Forced Flash, and Slow Sync.

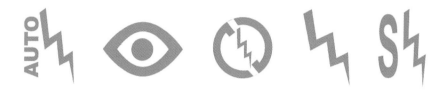

turn off the flash when shooting during concerts and other stage events; using the flash illuminates the rows in front of you (which you'll find distracting in the final image) yet does nothing to alter the appearance of the distant stage.

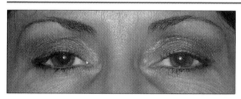

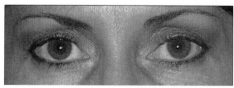

FIGURE 1.8

The photo on top shows red eye problems; the photo on bottom shows a photo taken with Red Eye Reduction on.

▶ **Forced Flash**—When your camera is set to Forced Flash (sometimes called *Always On* or *Anytime Flash*), the flash will always fire. You should use this setting when taking pictures of people outdoors, especially in shady areas, or when the subject is against a bright background.

▶ **Slow Sync**—When you shoot a nearby subject at night or in a dark room, choose the Slow Sync option (sometimes called *Night Portrait*). The flash fires to illuminate the subject, and then the shutter stays open for a moment longer so that the background doesn't appear to be solid black in the photo. Warn your subject to hold still until you say it's okay to move; otherwise, that slow shutter speed will cause a blur. And make sure the camera stays steady, too. It's a good idea to use a tripod or place the camera on a steady surface when shooting at night or in a dark location.

Some cameras offer additional flash modes. The ones described here are the five basic modes that are available on most of today's digital cameras.

NOTE

Did you notice the parallels between the shooting modes and the flash modes? Many cameras automatically coordinate the flash when you select a specific mode. However, your camera may require you to manually set the flash mode that is best for the shooting mode, or it may offer you the flexibility of changing the default flash setting. Check your camera's user guide for specific information.

Composing Your Image

Image composition refers to the arrangement of items in your photo. Is the person or flower or building directly in the center of the photo, or is it artfully arranged with other components in the scene? Is the person looking straight at the camera or gazing thoughtfully into the distance?

Don't get me wrong, a centered image of a person looking straight into the lens can be artful. But the cameras we have in mind for this book are a bit limited in the creative department. Control over aperture (the size of the lens opening), for example, is not typically available for cameras in this price range. While no substitute for an M.F.A. in photography (or even a class in creative photography at a community college or a community center), I have a few tips to help you take more interesting photos.

> **NOTE**
>
> What you're about to read should be considered suggestions and advice, not rules. Remember that every shot is unique—and trying to establish rules that govern *all* photos is a fool's game. And don't ever *not* take a shot because the composition isn't perfect—you may be able to improve it later on your computer.

Framing the Subject

The subject in a photograph is whatever or whomever you're photographing. It could be a specific object, such as a person, a flower, or a piece of jewelry. It could also be something broader and larger, like a mountain, a building, or a beautiful sunset. You *frame* the subject when you peer through the camera's viewfinder or look at the LCD screen. You aim the camera so that the subject (and surroundings) appear as you want them in the photo.

The subject might need to be placed in the center of the frame for flexibility in printing (which I discuss in Project 2, "Create Your Image Albums"), but consider placing the subject slightly to the side to add some visual interest to the image. In some cases, the subject might even fill the frame. Compare the photos in Figure 1.9.

You might come across *The Rule of Thirds* as you explore photography. It's a great way to create visually interesting images. Here's how it works:

1. **Imagine the image divided into thirds—** Look through your viewfinder or at your LCD display and imagine three columns and three rows, as shown in Figure 1.10.

2. **Consider the intersections—**Visualize the points where the edges of your imaginary columns and rows intersect. (In Figure

FIGURE 1.9

A centered subject, an off-center subject, and a subject that fills the frame.

FIGURE 1.10
This image divided into three columns and rows demonstrates *The Rule of Thirds*.

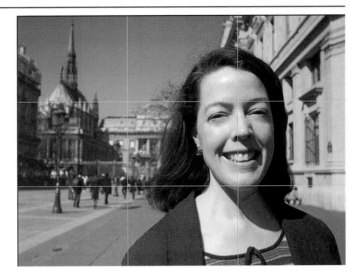

1.10, look at where the horizontal lines and the vertical lines meet.)

3. **Compose your image by using the lines and intersections**—As you frame your image, think of these intersections as key points, places where you want important details in the image. When photographing a person walking, for example, the subject may fall along a vertical line, with his or her head at one of the upper intersections.

Now, in keeping with the spirit of this section, let's change the name of this technique to *The Suggestion of Thirds*. Don't get so carried away with trying to compose using the lines and intersections that you let the shot get away!

When you're shooting a broad area, such as a mountain vista, you might want to frame the image to include interesting or identifiable objects in the foreground. Such objects give the image a sense of depth and perspective (see Figure 1.11).

NOTE

If you happen to be a forensic photographer working a crime scene, or an insurance adjuster documenting damage, or perhaps the booking officer at the precinct taking mug shots, you *don't* want to get creative with your photos—you need the best portrayal of reality your camera can produce. For the rest of us, a little creativity is a good thing.

Exploring Depth of Field and Offset Focus

Depending on the lens with which your camera is equipped, you might need to consider depth of field. *Depth of field* is the distance from the camera at which the image is in focus. Objects farther away (and closer) are out of focus and blurry. Consider the two examples in Figure 1.12.

FIGURE 1.11

FIGURE 1.11

With identifiable objects in the fore-ground, the back-ground has a relative depth and perspective. On the right, shadows and highlights produce depth.

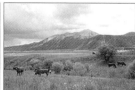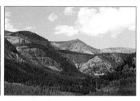

Remember that your camera probably looks at the center point when using auto focus. If the camera permits you to change the point of focus (see your user guide), change the focus point to your subject. Alternatively (and, gener-ally, this is easier), you can point the camera at the subject and press the shutter release button halfway down to focus, then—with the button still only halfway down—reposition the camera to frame your subject as you like it. When the camera is positioned properly, finish pressing the button down to take the photo.

Considering the Background

As you frame your shot, be aware of the back-ground—the objects and scene behind your

subject. You want to consider a number of factors:

- ▶ What is the content of the background? Is anyone visible doing something distracting?
- ▶ What is the composition of the back-ground? Is any object being cut in half by the framing?
- ▶ What is the interaction of the background with the subject? Does anyone have a lamppost growing out of his/her head?

The same concerns apply to the foreground when shooting a distant subject. So, *how* do you evaluate the composition? You frame the image in the viewfinder or LCD. Hold the camera still. Look carefully at all the image data in the viewfinder/LCD screen. Look at the corners as well as the center, making sure that the image is how you want it captured.

FIGURE 1.12

On the left, the background is in focus. On the right, the foreground is in focus. Quite a difference, eh?

A Word About Aspect Ratio

Aspect ratio is the relationship between width and height. Your camera captures a specific number of pixels wide and a specific number of pixels tall. (You'll find an extended discussion of aspect ratio in Project 2.) For most of the cameras that fall into the range we're discussing in this book, the width of the image is one-third greater than the height. That gives you an aspect ratio of 4:3. (Phrased another way, there are 100 pixels of width for every 75 pixels of height.) A print that's 6 inches wide and 4 inches tall has an aspect ratio of 3:2, and an enlargement that measures 10 inches tall and 8 inches wide has an aspect ratio of 5:4.

Both 4×6 and 8×10 prints chop off a little of your 4:3 digital image. Keep that in mind when composing your image! If you suspect that you'll want an 8×10 from the shot you're taking, make sure to leave some space at the top and/or bottom that can be omitted in the enlargement.

Take a look at Figure 1.13. On the left is a full-frame close-up. In the middle you see what happens when that close-up is cropped to fit into an 8×10 enlargement—part of the chin and hair are chopped off. On the right you see a close-up that's composed to allow for the cropping.

http://www.dpreview.com/learn/?/Photography_
techniques

DIGITAL PHOTOGRAPHY REVIEW

This site looks like any other digital photography site—a lot of cameras and peripherals—until you click on the "Learn" menu option. You can learn about infrared photography on your digital camera, fancy filters, and add-on lenses that you work with the flash feature. Maybe you're not quite up to spending more money on gadgets and gizmos to produce exotic photos, but this site does make anyone want to head to the camera store. If your pocketbook is thin, don't worry. They also have techniques that you can try without spending a dime, like creating multiple exposures with your digital camera.

FIGURE 1.13

Consider how you'll eventually use the image when composing a shot.

Photo Safari!

It's time to take some photos! You can use the photos you take in this part of the project later in this book, or you can use the sample images on the CD that accompanies this book.

> **NOTE**
>
> Please keep in mind that the images on the CD are copyrighted material. You are authorized to use them *only* for the purposes of practicing the lessons in this book. Any other use, personal or commercial, is not allowed, nor can the images be shared with or distributed to any other person or entity. (Thanks!)

Taking Portraits

A portrait can be a face-only shot, a head-and-shoulders shot, or even a seated formal photo. The idea is that the person in the shot is primary, and anything in the background is secondary. You can shoot portraits against decorative backdrops, a plain wall, or even outside. The location isn't as important as the composition—everything should be arranged to

produce the most flattering photo of the subject possible.

Here are some things to keep in mind when taking portraits with your digital camera:

▶ **Use the Portrait mode on your camera**— Set the dial or the menu to the Portrait mode (the stylized profile of a woman).

▶ **Use your flash**—If the Portrait mode for your camera doesn't automatically activate the flash, make sure to set your camera to the Forced Flash mode. Flash is especially important when shooting outdoors.

▶ **Turn the camera sideways**—Rotate the camera 90 degrees for most portrait photography. That enables you to maximize the subject and minimize the extraneous background to the left and right. (Photos taken with the camera rotated 90 degrees are said to be in *portrait* orientation, rather than the standard *landscape* orientation.)

▶ **Control the ambient lighting as much as possible.** If shooting outdoors, move into an area of shade rather than direct sunlight. Not only does this help prevent harsh shadows, it also helps your subject keep his or her eyes open. Indoors, you might want to position your subject near a

window to provide some side lighting (but don't seat the subject in direct sunlight).

▶ **Angle the subject's head**—You'll generally find that having the subject turn his or her head a little to the side, perhaps facing 30 degrees away from the camera, provides a more flattering shot (see Figure 1.14). The head can be tipped up a bit (especially for those with a little extra along the jowls) or tipped down to emphasize the eyes.

▶ **Take lots of shots**—It's amazing how different several shots in a few moments can be! A squint, a smile, a slight change

in the angle of the head, or a combination of many things can be the difference between a nice photo and a great portrait.

It's time to practice! Take a few shots, following these steps:

1. **Select a subject**—Get a volunteer (or draftee) who has a few minutes to spend, perhaps in return for some very nice photos. You probably don't need more than 10 or 15 minutes to finish this exercise.

2. **Take a sample red eye shot**—Start with an intentional mistake, a red eye shot that you'll use later in this book. Set your camera to Auto mode and set the flash to Forced Flash (the single lightning bolt symbol). Working in a somewhat dark room or outside in twilight, position yourself about 5 feet from your subject and have the subject look directly into the lens. Press the shutter release button halfway down to focus and then all the way down to capture the shot. You can use this photo later to test your software's red eye reduction capability.

FIGURE 1.14

Compare a straight-on "mug shot" and a casually posed portrait.

http://www.imaging-resource.com/
IMCOMP/COMPS01.HTM

IMAGING RESOURCE

This site displays side-by-side photographs taken by two different cameras for comparison. Their list is extensive and up-to-date; so if you can't choose between the Nikon Coolpix and the Canon Powershot, go to this site and compare them. You can preview images photographed with a flash, snapped indoors and outdoors, and shot in close-up. You can also preview various special camera features that may be the deciding factor when it's time to purchase a new camera.

3. **Test your Red Eye Reduction flash mode**—Set your camera to Portrait mode and check the flash setting. If the flash isn't automatically set to Red Eye Reduction, make the change manually. Take the same shot. (Warn your subject about the pre-flash and instruct her or him to remain still until after the second flash.)

4. **Shoot a seated portrait**—This is the "money" shot, the one that your subject will love forever. Position a chair near some windows (but not in direct sunlight). You want the windows to the side of the chair. (And make sure that the chair is at least 3 feet from any wall behind it.) Seat your subject in the chair with his or her body pointed toward the front, toward the camera, hands loosely folder in the lap. Have the subject turn her or his head slightly toward the window, so that the angle from the camera is about 30 degrees. Your setup should look (more or less) like that shown in Figure 1.15. Have the subject relax and look thoughtful, perhaps tipping the head slightly toward or away

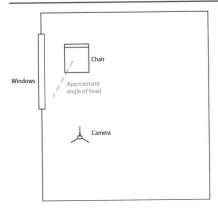

FIGURE 1.15

Depending on your available space, the layout can certainly be reversed.

from the camera. Take the picture. And then take two or three more with slightly different head positions.

5. **Practice outdoors, too**—Move outside to a shady area, perhaps in the shadow of a building or under a tree. Make sure that your camera's flash is set to fire in either Red Eye Reduction or Forced Flash mode. Position the subject looking off into the distance, again at a slight angle to the camera. This is a great time to practice composing the background; make sure that the subject is positioned so that there won't be any major distractions behind him or her. Shoot this one from about the waist up. (If the person is somewhat large, the body should be square to the camera. If the person has a nice figure, the body can be angled away from the camera, in line with the head.) Remember to leave some empty space above the head so that the image can be cropped to an 8×10 if so desired. Take a few more shots at different angles and from different directions. (Remember, this is digital—you're not wasting film when taking additional shots.)

Shooting Landscapes

The term *landscape* has a couple meanings in digital photography. It can refer to the orientation of a photo. (Remember that in *landscape* orientation, the longer side runs along the top and bottom. If the shorter edge is at the top and bottom, the orientation is said to be *portrait*.) It can also refer to the content of the image. Landscapes are not restricted to distant mountains and city skylines. The term can also be used with photos of gardens, forests, beaches, and just about any outdoor shot

where the background, rather than a specific subject in the foreground, is the focus.

TIP

It's a great idea to spend a little money on a second battery and another memory card. Keep the spare battery charged and store both the spare memory card and battery in your camera case. Few things are as frustrating as not being able to take a great shot because your battery is dead or your card is full. This is especially important when you hit the road to take shots away from the computer; unless you take a laptop or specialized device with you, you don't have any way to download your images to empty the card.

After you make sure there's a charge in your battery and free space on the camera's storage card, let's hit the road! Actually, we'll start with some close-to-home practice shots:

1. **Shoot the house**—Walk out the door, cross the street (carefully!), and get ready to take a shot of your house (or another in the neighborhood). If your camera has a zoom function, you'll want to zoom out and set it as short (wide) as possible so that you capture as much of the block as possible. Compose the shot. (Unless you have a beautiful blue sky with a couple fluffy clouds, you probably don't want to include too much sky in your image.) Take the shot.

TIP

When shooting a subject that's more than 10 feet away, your camera's flash is likely too far away to contribute to the lighting. Shut off the flash in such situations to save battery power.

2. **Get creative with the house**—Cross back over to the other side of the street and take an angled shot from near the corner of your house. For example, compare the two shots in Figure 1.16.

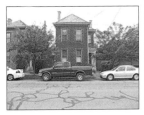

FIGURE 1.16

The image on the left is good for documenting your house, as a realtor might, but the shot on the right seems more creative.

3. **Wander down to the park**—If you have a nice park in the neighborhood, take advantage of it. Flower gardens, stands of trees, and ponds all make great subjects for digital photography.

4. **Photograph the skyline**—It doesn't matter whether you live in a city or a town— there's something special about a skyline (see Figure 1.17).

Capturing a Group Shot

If you take your camera to work or school, you might find a great opportunity to practice taking group photos. Whether you're shooting 2 or 20 people, there are a couple things to keep in mind when taking a group photo:

▶ **Arrange the group**—Some people will gravitate to the front, others to the back. Arrange them so that everyone is visible. If you have a shy short person trying to fade into the crowd, that's fine—don't force the person to the front row if he or she doesn't want to be there. Instead, make sure that there's a gap in the front to let the person behind show through.

▶ **Consider the nature of the gathering**— You might want to shoot a group picture of the local choir in their robes a bit differently than you would a postgame barbeque. In a more formal setting, you'll

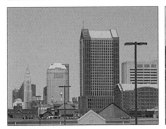

FIGURE 1.17

On the left, a midsize city skyline. On the right, a small town "skyline." Both are visually interesting.

want to regulate the spacing of the individuals to create uniformity. In an informal gathering, overstructuring the group can make the photo seem staged and stiff, perhaps unlike the nature of the event.

▶ **Stay away from walls!**—If shooting indoors, make sure that there's at least 3 or 4 feet between the back of the group and the nearest wall. You don't want your flash to create shadows on the wall behind. For example, compare the images in Figure 1.18.

Compensating for a Bright Background

When your subject is in shadow and the background is brightly lit, you may end up with the result shown on the left in Figure 1.19. Before taking the shot, set the camera to Forced Flash (the single lightning bolt icon) to add fill flash. *Fill flash* lights the subject and allows the

camera to capture the subject properly (as on the right in Figure 1.19) .

Getting a Close-up

You can use your camera's Close Up mode (the flower icon) to take pictures of small objects from close range. In addition to flowers and interesting bugs (don't get *too* close!), you can use Close Up mode to create a visual record of valuables, such as jewelry. You can make prints or create CDs of the images and store them someplace safe, such as a bank's lock box, or send them to your family attorney for safe-keeping.

When taking close-ups, a couple questions require attention:

▶ **What is your camera's minimum focal range?**—The *focal range* is the distance between the camera and the subject within which the lens can properly focus. The

FIGURE 1.18

Moving the family just a foot or two farther from the wall minimizes the distracting shadows.

FIGURE 1.19

When the subject is in the shade, use your flash.

closest you can get to a subject with some cameras is a couple feet. However, in Close Up mode, that distance might drop to as close as a couple of inches! The zoom factor you're using may also play a role. The maximum distance for almost all cameras can be considered to be infinity—the lens can focus on the moon and beyond.

▶ **Should you use flash?**—The flash unit on your camera can reach as far as 10 feet— and that makes it a little too powerful for 2 or 3 inches. Photographing flowers outdoors is often best done with natural light, while documenting the family

valuables might be more easily accomplished with a couple table lamps and perhaps a small tabletop tripod (see Figure 1.20).

TIP

When photographing shiny things, large or small, wear dark clothing to minimize your own reflection. Yeah, *that's* why photographers always wear black. It doesn't really have anything to do with looking cool, protecting the Earth from aliens, or using the right shampoo.

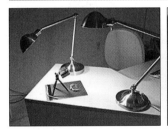

FIGURE 1.20

A tabletop tripod not only frees your hands, it also helps provide a more stable base for the camera.

CHAPTER 2

Create Your Image Albums

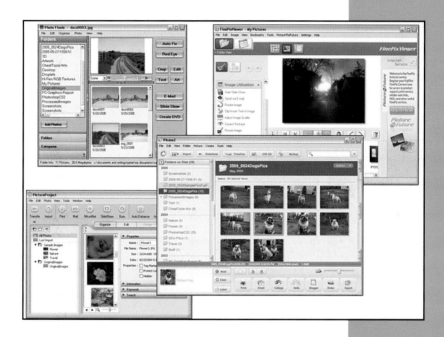

Odds are, your digital camera came with a CD containing software for working with digital pictures on your computer. (In fact, just about every digital camera sold these days includes at least one program on CD or available for download from the manufacturer's website.) You can also use free software, including Picasa from Google, to download and organize pictures.

Image editing software typically enables you to perform a variety of tasks, such as these:

- Download images from the camera to your computer

- Organize your images into sets, perhaps called projects, collections, folders, or albums

- Print images

- Create slideshows of your images

- Rotate pictures

- Crop pictures (*Cropping*, which is discussed in more detail in Project 3, "Taking the Next Step: Improving Your Pics," cuts away unwanted parts of the image, reducing the total size of the picture.)

- Eliminate red eye

- Add captions or put your pictures into various layouts or templates

- Create panoramas from two or more pictures

The specific program that came with your camera may not have all these features but is likely to have three critical capabilities: download, organize, and print. Some of the available image editing software is shown in Figure 2.1.

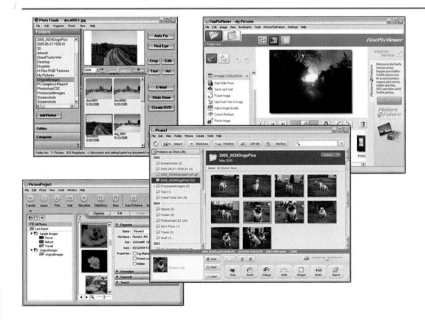

FIGURE 2.1

There are lots of different programs available for working with digital photos.

Your camera may also have come with a free or trial version of more advanced image editing software, such as Adobe's Photoshop Elements, ArcSoft's PhotoStudio, or Trevoli's Photo Finale. Such programs give you near-complete control over the appearance of your pictures, enabling you to manipulate and edit the content of your images to your heart's content. (You can read about this in Project 5, "Advanced Image Editing.")

Exploring Image Editing Software

Each camera manufacturer supplies its own software with its cameras. If you own a Nikon camera, you probably have a CD that contains PictureProject software. FujiFilm FinePix cameras generally have the aptly named FinePix Viewer software included. Canon provides ImageBrowser with some PowerShot cameras and ArcSoft software with others. Panasonic, Olympus, Casio, Minolta, Pentax, and other brands have their own software, too. For this project, you can work with your own software or with the free Picasa software that is available on this book's CD or via direct download from www.picasa.com.

> **TIP**
>
> **It's a good idea to familiarize yourself with your software before diving right in. If your camera's user guide doesn't provide information about the software, check the CD on which the software came for a PDF manual.**

Installing Picasa

Before you can start using any software, it needs to be installed on your computer. To install Picasa, follow these steps:

1. **Download the software or insert the CD**—If you're installing from the CD, you'll find Picasa in the Software folder. By the time you read this, there may be an updated version of Picasa available for download, so you might want to check www.picasa.com.

> **TIP**
>
> **If you're most comfortable when your computer screen looks exactly like the pictures in this book, use the version of Picasa on the CD.**

2. **Double-click the Picasa .exe file**—The filename before the .exe file extension will vary, depending on what version of Picasa you install. If you're installing from the CD, the filename is picasa2-setup-1884.exe.

3. **Reassure Windows that you do, indeed, want to run the file**—Your antivirus software will probably warn you about running an .exe program. However, you do need to click the Run button (see Figure 2.2).

4. **Agree to the licensing terms**—The next window you see during the installation procedure is the licensing agreement. Read the terms and then click the I Agree button.

5. **Use the default install location**—Windows offers the opportunity to install Picasa anywhere on your hard drive. I suggest that you install into the default location.

At MyPublisher, you can download free software and use it to lay out attractive photo albums that range from $10–$60. They offer templates from paperback pocketbooks, to more expensive hardcover albums, to deluxe books. Their process is pretty easy. Download the software, upload your photos, edit your photos, and lay out your book with your choice of 80 different templates. Send it off to the company to produce your book. Simple!

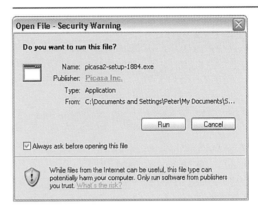

FIGURE 2.2

Your antivirus software is just trying to protect you!

6. **Finish the installation**—Make sure that the Run Picasa2 box is selected so that the program launches and you can get right to work. Then click the Finish button (see Figure 2.3).

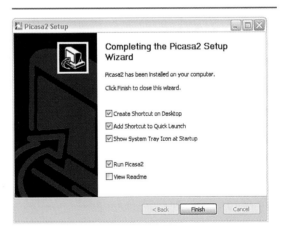

FIGURE 2.3

Adding a shortcut to the Desktop makes it easier to launch Picasa.

NOTE

Opting to view the readme file launches your Web browser and takes you to the Internet.

Welcome to Picasa!

After you click the Finish button at the end of the installation process, Picasa starts, and you can get to work! The first thing Picasa wants to do is find pictures already on your hard drive. As you see in Figure 2.4, Picasa asks you where you want it to look for pictures as it creates a database of image files on your computer.

NOTE

Picasa doesn't move files as it searches your computer; it just creates a database of the location of each file.

Generally speaking, you want to restrict Picasa's search to the My Documents folder, the My Pictures folder, and the Desktop. If you have Picasa search the entire computer, you not only have to wait longer, you end up with a database that includes a lot of images files that you don't need to know about. Take a look at Figure 2.5, for example. Picasa searched the entire computer and added to the database such files as examples from the Help folders of various programs and even demonstration movies from an old version of Microsoft Works installed on the computer in 2002!

After Picasa strolls around the computer, looking for image files, you see all the pictures it found, organized into folders according to location and sorted by date (see Figure 2.6). You can click a folder in the left-hand column to display the images in the preview area to the right. And along the right-hand edge of the Picasa window, you have a scrollbar available to move up and down among your images.

FIGURE 2.4

Picasa can look everywhere for image files to add to its database, or it can look only in places that are most likely to include pictures you actually want to add to the database.

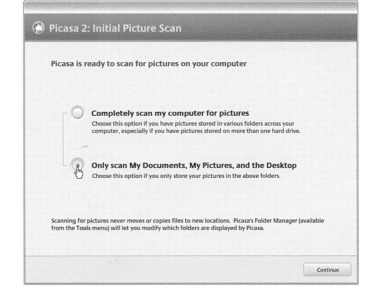

Picasa 2: Initial Picture Scan

Picasa is ready to scan for pictures on your computer

○ **Completely scan my computer for pictures**
Choose this option if you have pictures stored in various folders across your computer, especially if you have pictures stored on more than one hard drive.

◉ **Only scan My Documents, My Pictures, and the Desktop**
Choose this option if you only store your pictures in the above folders.

Scanning for pictures never moves or copies files to new locations. Picasa's Folder Manager (available from the Tools menu) will let you modify which folders are displayed by Picasa.

Continue

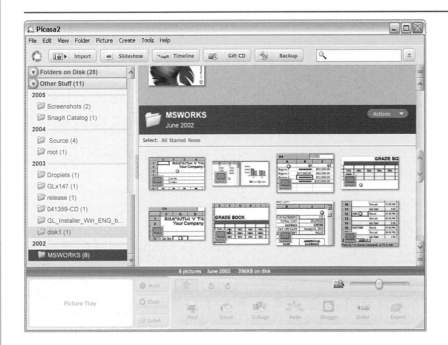

FIGURE 2.5

If Picasa searches the whole computer, the database ends up including files about which you probably don't care.

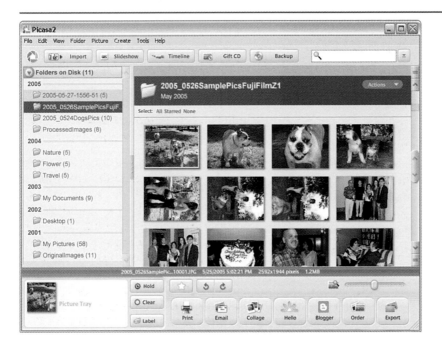

FIGURE 2.6

Picasa sorts and organizes according to both year and the location on your hard drive.

Even if you restricted the Picasa search to the My Documents folder, the My Pictures folder, and the Desktop, there's a possibility that the database includes folders of images that simply clutter up the display—images with which you don't want to work or display. You can stream-line the database by going to Picasa's Tools menu and selecting Folder Manager (see Figure 2.7).

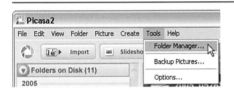

FIGURE 2.7

To remove folders from the Picasa database, use the Folder Manager.

In the Folder Manager, click the name of a folder on the left and then click the Remove from Picasa option on the right, as shown in Figure 2.8. The folder and its content remain on your computer—Picasa doesn't delete them—but Picasa ignores the folder in the future.

By default, Picasa assumes that you want to continue to watch folders that contain images; in this case, Picasa automatically updates the database as the contents of the folders change. In some cases, you might want Picasa to scan a folder once to determine the content but not watch the folder; you choose the Scan Once option for any such folders. Click OK to close the Folder Manager when you're finished.

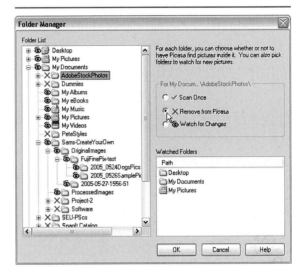

FIGURE 2.8

If Picasa found folders you don't want in the data-base, you can remove them from Picasa (without deleting the files from your computer).

Downloading Images from Your Camera

Now it's time to move pictures from your digital camera to your computer by using Picasa! Here's what you do:

1. **Connect your camera to the computer—** Make sure that your camera is turned off, and then connect the cable that came with the camera to the camera and then to the computer. (If you're uncertain about the procedure, check the user guide that came with your camera.) Some cameras connect directly, while others use a *cradle* or *dock* in which the camera sits. You might also use a *card reader* to download image files. (See the sidebar "Getting Connected" for more information.)

Many digital cameras plug right into your computer by using a USB cable (typically supplied with the camera). The cable may have one tiny connector to plug into the camera and a standard USB connector at the other end to connect to the computer.

However, there are other ways to connect a camera to a computer. Some cameras use a *cradle* or a *dock*, a separate piece of hardware that's connected directly to the computer. The cradle/dock stays connected (if you want to leave it connected), and you put the camera in the device to charge the camera's battery and to download images.

Another alternative is a *card reader*. To use a card reader, you remove the recordable media from the camera and insert it into the small device, which remains connected to the computer. Many card readers can be used with different types of recordable media, making them very handy if you have multiple cameras. And, generally speaking, card readers download images to the computer *much* faster than camera-to-computer connections.

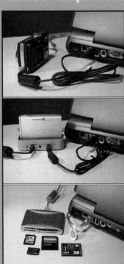

From top to bottom: a direct connection, a cradle/dock, and a card reader with various recordable media.

2. **Turn on the camera**—Windows should automatically recognize the camera. It is likely to launch the software that came with your camera. Quit that program and switch back to Picasa.

3. **Click the Import button**—You'll find the Import button toward the upper-left of Picasa's window (see Figure 2.9). You then see a menu with locations from which you can import images (which is discussed in the next step).

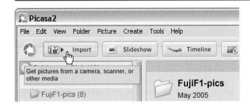

FIGURE 2.9

You can use the Import button to download pictures from your digital camera.

4. **Select your camera from the Select Device menu**—As you can see in Figure 2.10, your camera may be listed by name or it may appear as Removable Drive (which is also visible if you use a card reader to transfer your images). Picasa then gathers the images available on your camera.

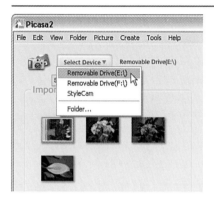

FIGURE 2.10

Picasa sees some cameras by name, but in this case, two additional cameras are listed as Removable Drive.

5. **Preview, rotate, and exclude as desired—** Click an image in the Import Tray area to the left in Picasa (see Figure 2.11). Use the

left and right arrow buttons below the preview area to navigate among the images. Use the rotate buttons to change the orientation of images (or you can rotate at a later time in Picasa). If there are any pictures you don't want to import, select the images in the Import Tray and click the Exclude button. A red-and-white X symbol indicates an image that will not be imported.

6. **Click the Finish button—**After you have rotated and excluded images that you don't want to import, click the Finish button to move to the next step in the process.

7. **Name the folder and complete the download—**In Picasa's Finish Importing dialog box (see Figure 2.12), naming the folder in the Title field is mandatory—the Finish button isn't available until you assign a title—and you can add any additional

FIGURE 2.11

The first and last pictures are rotated, the third picture is excluded and will not be imported.

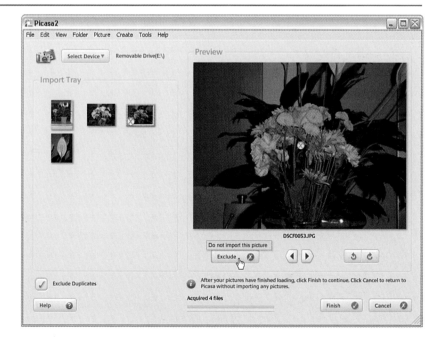

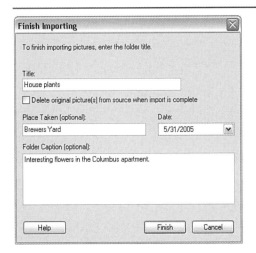

FIGURE 2.12

A folder title is required, but the other fields are optional.

information you want in the Place Taken and Folder Caption fields. Click the Finish button when you're done to complete the import. Picasa imports each download into

a new folder, just like the ones created when you scanned your computer for existing pictures earlier.

8. **Disconnect and remove your camera—** Before turning off or disconnecting your camera, always use the Safely Remove Hardware shortcut in the Quick Launch area in the bottom-right corner of the screen (see Figure 2.13). After a couple seconds, Windows lets you know that it's safe to shut down and unplug. (And, yes, turn off the camera before disconnecting the cable or removing the camera from the cradle/dock.)

CAUTION

Always follow the proper shutdown sequence before disconnecting the camera from the computer. While there's little chance of damaging your camera or computer, you should err on the side of caution.

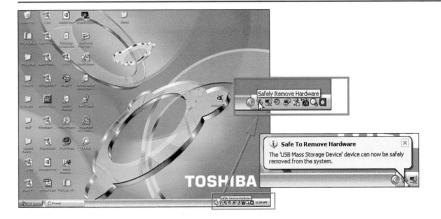

FIGURE 2.13

Click the Safely Remove Hardware shortcut, select the device, and wait for the Safe to Remove Hardware message before turning off and disconnecting your camera.

FIGURE 2.14

Using labels and stars can help you keep your images organized and create digital photo albums.

9. **(Optional) Label your images to create albums**—After Picasa imports the images, you can click one or more image previews and then use the buttons at the bottom of the Picasa window to add labels (see Figure 2.14). If you like, you can also add stars to signify the best of the best. When you assign a specific label to an image, it's like copying the image to a different folder—a great way to create albums for slideshows (see step 10). You can assign pictures from many folders the same label and then view them as a group.

10. **(Optional) View a slideshow of your new images**—Click the Slideshow button (see Figure 2.15), and, Picasa shows you each of the pictures in your folder, in order, full screen! It's a great way to not only review the images but also show them to friends and family. Remember that you can use Slideshow with Labels or folders of images.

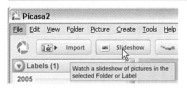

FIGURE 2.15

You can play a slideshow to see your images in sequence.

> ### TIP
> If you think Slideshow view is cool, click the Timeline button for a fun way to navigate among your folders to select one for a slideshow!

11. (Optional) **Create a backup CD of your images**—If your computer has an optical drive that is capable of recording to CD or DVD (called *burning* a disk), you can easily create a backup copy of your pictures for safe storage. Select the folder you want to back up and then click the Backup button. Picasa tells you which folders and files have not yet been backed up and walks you through the process of burning the disk.

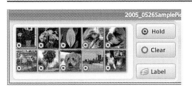

FIGURE 2.16
You can click the Hold button to keep images in the Picture Tray, even when switching folders.

TIP

Use Picasa's Backup button to create a CD of images to take to your local photo lab for printing.

TIP

Did you notice the Clear button in Figure 2.16? If you decide you don't really want to keep a specific image in the Picture Tray, click it in the Picture Tray to select it and then click the Clear button. If you want to empty the Picture Tray, make sure no individual picture or pictures are selected and then click Clear.

12. (Optional) **Collect pictures in the Picture Tray**—As you may have noticed while working in Picasa, any time you click an image in the large area to the upper right, it also appears in the lower-left corner of the Picasa window. (Go ahead and try it— click any image in the current folder.) That area to the lower left is Picasa's *Picture Tray*. Images in the Picture Tray can be easily printed, emailed to friends and family, blended into a photo collage, exported to a folder, and otherwise shared from within Picasa. But odds are, you'll want to work with more than one image at a time. To gather a number of images in the Picture Tray, select them in the upper right and click the Hold button (see Figure 2.16). Images that you're holding in the Picture Tray are identified there with a small green symbol. You can then even switch to another folder and select more images, and again click the Hold button.

13. (Optional) **Email pictures from the Picture Tray**—Once you've gathered images in the Picture Tray, you can quickly and easily email them to friends and family. Simply click the Email button (to the right on the Picture Tray) and select which email account you want to use (see Figure 2.17). You can use the email program that's on your computer (Outlook Express, in this example) or one of the Google-sponsored email services (Gmail and Picasa Mail). Picasa makes email-friendly smaller copies of the selected images to avoid overloading anyone's email Inbox.

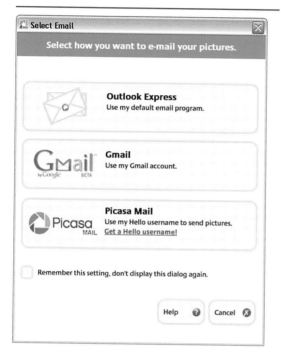

FIGURE 2.17

You can click the Email button in Picasa and then choose which program or service to use.

TIP

You can access Picasa's online service for sharing, distributing, and printing your photos by using the Hello, Blogger, and Order buttons.

For more information about these services, check Picasa's Help.

TAKING PICTURES OF YOUR PET

http://photographytips.com/page.cfm/95

GET YOUR DOG TO STRIKE A POSE ARTICLE ON DOG PICTURES

http://www.dog-pictures.org/photographing_your_dog.cfm

Pets aren't always easy to photograph. First of all, few of them are willing to pose for a picture. Second, their eyes sometimes show up in the photograph with a strange greenish shine. This site offers all kinds of photography tips, including ideas on how to take portraits and spontaneous pictures of your pet. While researching this topic, I also remembered an article from *Martha Stewart Living* a few years ago on taking pictures of your dog. Luckily, I found it on the Web. Check out the article on Dog Pictures. This site also has some beautiful pictures of many breeds of dogs.

14. **(Optional) Export pictures from the Picture Tray**—You might want to make a new folder with copies of the images you've gathered in the Picture Tray, perhaps to use in a project or maybe to manually create a backup. After selecting images and holding them in the Picture Tray, click the Export button (to the far right of the Picture Tray). As you can see in Figure 2.18, you can assign a name to the new folder, click the Browse button to choose a location for it, and even elect to resize the images and assign an image quality percentage.

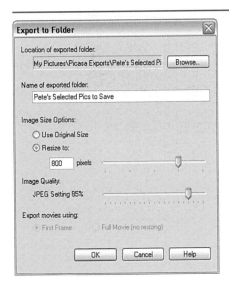

FIGURE 2.18

Exporting images to a folder is great for gathering materials to use in creative projects.

NOTE

The Image Quality slider shown in Figure 2.18 balances image quality and file size. Compare the close-ups of two images, 85% Image Quality (46KB file size) on the left and 10% Image Quality (15KB file size) on the right:

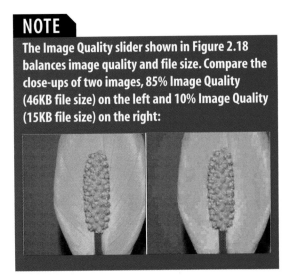

Printing Your Images

While viewing pictures on the computer is great, there's nothing quite like having a set of prints in a nice album or a large print nicely framed and hanging on the wall! You can take your camera's recordable media or a CD of your images to the local photo lab for printing. You can order prints online from a number of services (even through Picasa). Or you can print your images yourself, right at home.

Picking a Printer

If you'll be printing snapshot-sized photos, a dedicated photo printer is a good bet—not very expensive to purchase or operate, not too complex to master. If you'll want to print larger copies of your images, perhaps 8×10, you'll need to look at photo-quality inkjet printers.

Poster-size prints require large-format printers (and more sophisticated software). If, on the other hand, you'll find yourself using your digital photos in projects that require a large number of prints, such as newsletters, brochures, and handouts, a color laser printer may make sense in the long run. (A good color laser printer requires a substantial initial investment, but the cost per print is much, much lower than with an inkjet printer.)

Photo printers typically print on special paper, precut to the standard 4×6 inches. You don't need to connect the printer to a computer—you simply remove the media card or stick from your camera (carefully!) and insert it into the appropriate slot on the printer (see Figure 2.19).

Most photo printers are small enough to be easily transported, yet they produce photo-quality output (see Figure 2.20). Some have an LCD panel that lets you preview each image in order to choose which to print. Other models generate an index print (or *contact sheet*), which contains small versions of the pictures on the camera's card. You can also preview images in your camera to determine which ones you want to print.

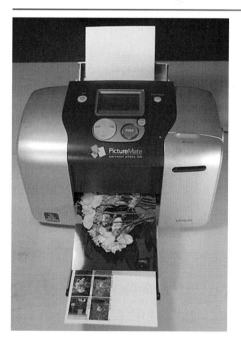

FIGURE 2.19

This sample printer, the Epson PictureMate, handles just about any type of digital camera media except CDs and mini-CDs.

FIGURE 2.20

About the size of a small lunch pail (and with a carrying handle!), the Epson PictureMate produces photo-quality 4×6-inch prints at a low cost per print.

WHAT IS *ASPECT RATIO?*

Regardless of how you have your prints made, you need to pay attention to the image *aspect ratio*. That's the relationship between the width and height of your images. Your digital camera may use as aspect ratio of 4:3, where the image is one-third wider than it is tall. More expensive cameras may use the 3:2 aspect ratio, comparable to 35mm film, where the image is 50% wider than it is tall. Or perhaps your camera shoots in a 5:4 aspect ratio, with images that are 25% wider than they are tall.

Why is this important? Remember that an 8×10 print has an aspect ratio of 5:4. If you request an 8×10 print from an image with an aspect ratio of 4:3, you will either lose some of the image or have a 0.25-inch white border along the top and bottom. Take a look, for example, at these two versions of an image captured in 4:3 aspect ratio:

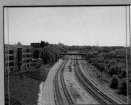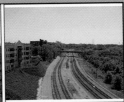

On the left, the red border shows what would be included in an 8×10 print. On the right, you see the white border that would result if the entire width of the image were printed on an 8×10 sheet of paper.

An 8×10 print of an image captured with a 4:3 aspect ratio presents a minor dilemma. The option on the left, cropping the edges, is usually the preferred choice. If your camera captures images using a 5:4 aspect ratio,

TIP

You'll want to keep aspect ratio in mind when taking pictures. If you zoom out a little and capture a little more of the scene, cropping a bit when making prints won't be a problem.

For the versatility to create prints at sizes up to 8×10 inches, choose an inkjet printer. Look for a printer that uses at least six colors and generates *archival* prints (see the sidebar "How Long Will My Prints Last?" later in this project). High-quality, inexpensive inkjet printers are available from Epson, Canon, and Hewlett-Packard, among others. Generally speaking, you'll print to an inkjet printer from your computer rather than directly from a camera.

Here are some of the features you might run across as you shop for an inkjet printer:

▶ **Resolution**—*Resolution* indicates the number of ink droplets placed on the paper in a square inch. You'll see a wide range of figures, often in pairs such as *4800×1200 dpi* or *5760×1440 optimized dpi* (*dpi* stands for drops per inch). As long as the first number (the horizontal resolution) is at least 1440, you'll be getting a quality print.

NOTE

Don't confuse inkjet printer resolution with your image resolution! Inkjets measure droplets of ink per inch (*dpi*), while digital image resolution is measured in pixels per inch (*ppi*). (A *pixel* is a single tiny square of color in the image.) Image resolution doesn't need to be any higher than 300 ppi, while an inkjet's resolution may be 10 or 20 times as high. It takes quite a few droplets of ink to reproduce a single image pixel.

▶ **Borderless**—Borderless printing, also called *border-free* or *edge-to-edge* printing, fills the paper with ink, producing prints with no white margin around the outside. Be aware that most borderless printers slightly expand the image when printing so that no whitespace is left along edges. This means that any critical detail along those edges, such as fancy edge effects you add, might get chopped off. This is not generally a concern with snapshots.

▶ **Six (or more) inks**—Less expensive inkjet printers may use only four inks. Printers with six or more colors of ink produce more variations in color and, therefore, generally more pleasing prints.

▶ **Roll paper**—Printers that use roll paper not only can produce banner-length output, they can save you some money. Generally speaking, roll paper is cheaper than precut sheets.

▶ **CD printing**—Some printers, including a number of models from Epson, can print right on CDs and DVDs. You need to purchase discs on which you can print, of course (see Figure 2.21). Custom labels, printed right on the CD, are a great way to finish off those digital photo albums!

▶ **Grayscale**—Printers that use both black ink and light black or gray inks are generally capable of producing grayscale prints (like old-fashioned black-and-white photos) much better than printers not designed for the job.

an 8×10 print is perfect—the image exactly fills the page. A 3:2 image loses even more off the sides than does a 4:3 image.

So, how do you determine the aspect ratio of your images? If you purchased your digital camera recently (and paid more than a few bucks for it), it likely captures in a 4:3 aspect ratio. To verify, take a look in the camera's user guide for the exact pixel dimensions of the images. Divide the smaller number by the higher number and note the resulting decimal number. The decimal 0.75 indicates an aspect ratio of 4:3; 0.67 indicates an aspect ratio of 3:2; 0.80 indicates an aspect ratio of 5:4.

And what about the other popular print sizes—how do they work with your digital images? Take a look at this figure to see how a camera's aspect ratio works with standard print sizes:

Image Aspect Ratio	Print Size			
	3.5×5	4×6	5×7	8×10
5:4				
4:3				
3:2				

The shaded areas indicate what areas of the digital image will be cropped for prints at specific sizes.

FIGURE 2.21
CDs and DVDs on which you can print (with certain printers) have a plain white surface for the ink.

TIP

If you don't own a printer that's designed to produce grayscale prints, but that's what you need, burn a CD with the image files and head to your local photo lab. Trying to produce acceptable grayscale on an inkjet printer not designed for the job is an exercise in frustration (and often a waste of money).

Paper, Inks, and the Cost of Printing

One aspect of purchasing an inkjet printer that's rather hard to nail down is the actual cost of operating the printer. How much does it cost per print? Many of the small photo printers advertise the cost per print, but it's a different story with inkjet printers. Most inkjet printer manufacturers seem reluctant to make specific promises about how many pages you'll get from a single ink cartridge. And that's with good reason! The content of the image plays a large role in how much of which inks will be used. (Consider the difference, if you will, between a series of landscapes that include large areas of beautiful blue sky and another set of landscapes captured on a bland, overcast day. Reproducing blue skies takes more colored ink than does adding some gray highlights to a cloudy sky.)

CAUTION

While it may be tempting to purchase discount inks or bulk ink to refill your cartridges, I advise against the practice. Using ink other than that made for your printer will void the warranty and may cause damage to the printer.

It's difficult to estimate your ink costs, but you can easily calculate the cost of paper: Simply divide the package cost by the number of sheets in the package. *Plain paper* is the least expensive (sometimes less than $0.01 per letter-size sheet) but is not suitable for photographic prints. (You'll want to have some on hand for printing pages of text, such as email, and perhaps interesting information from the Internet, but plain paper just isn't thick enough for a photo print.) *Glossy* and *semiglossy* papers have a shiny surface that's great for photos, but they are also the most expensive papers (up to $1 per 8.5×11 inch sheet). *Matte* papers, with a non-glossy surface, generally range from $0.20 per sheet to several dollars per sheet for specialty papers. Heavyweight matte paper, at about $0.35 per sheet, is an excellent choice for your general photo printing needs. Using papers recommended by the printer's manufacturer will generally give you excellent results, but there are some wonderful inkjet papers available from other sources, too.

Mounting Images in an Album

After you print your photos, you might want to put them into a nice photo album. When purchasing an album, you're likely to run across three basic types: Each page may have *sleeves* or *pockets* into which you slide each print, the entire page may be covered with a clear film that holds photos in place, or the pages may be completely empty. With plain pages, you should mount your pictures by using *photo corners*—those little triangular

HOW LONG WILL MY PRINTS LAST?

Sooner or later (if it hasn't happened already), you'll run across the term *archival* in relation to photo printing. Think in terms of "How long will this image last before it starts fading?" A number of factors are involved, including how the print is created and how it is stored or displayed. An archival print can be expected to resist fading for 100 years or more when displayed properly. Inkjet printers that make the claim of producing archival prints use inks (or dyes) specifically formulated to resist fading.

Keeping your prints in an album with *acid-free* paper (paper that doesn't contain chemicals that ruin photos) and storing the album properly will ensure that just about any prints last for years. How many years depends on the inks and paper used to produce the prints. Prints from your local photo lab can last for a decade or more without fading noticeably. Prints from many photo printers have about the same longevity, although some (like the Epson PictureMate) produce archival prints.

But great photos deserve to be displayed! If you're planning on hanging your prints for the world to see, use an inkjet printer that creates archival prints or ask your photo lab if it can produce archival prints (at a reasonable cost). When purchasing frames, look for glass that's labeled *UV resistant*. Screening out ultraviolet light can help your prints last for generations. For the best of the best, consider having the print matted and framed by a professional. Check your phonebook for "Framing."

corners that hold the image in place (see Figure 2.22)—rather than adhesive strips, glue, or tape. This way, you can later move the prints to another album without damage. When purchasing *any* album, look for the terms *acid free* and *PVC free* (for albums with sleeves or transparent cover films) to ensure that your photos won't quickly degrade.

Photo albums with blank pages (with which you use photo corners) and those with a film overlay offer the most versatility. Rather than have each photo in its sleeve (some probably rotated in the wrong orientation), you can place photos in more artistic and more pleasing arrangements (see Figure 2.23).

Remember that photo albums, like any treasured book, should be stored properly. Avoid direct sunlight, high humidity, and excessively dry areas.

> **TIP**
>
> For your most important images, look for mounting and storage materials labeled *PAT approved*. That means the material has been proven safe for your photos by passing the Photographic Activity Test of the Rochester Institute of Technology's Image Permanence Institute.

FIGURE 2.22

Avoid using glue or tape to hold your photos in an album.

FIGURE 2.23

Sleeveless album pages let you get more creative.

CHAPTER 3

Taking the Next Step: Improving Your Pics

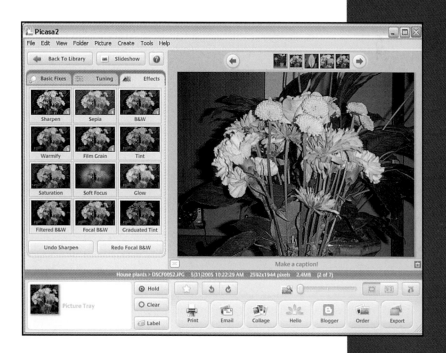

Your digital camera likely came with software for downloading, organizing, and printing your photos (as discussed in Project 2, "Create Your Image Albums"). That software probably has a few other tricks up its sleeve—features that enable you to make important changes to your photos. You can likely straighten a crooked photo, crop away unnecessary parts of a shot, improve the color and contrast, and eliminate the spooky red eye effect that's caused by flashes. The program might even offer cool special effects, such as sepia toning, focus adjustments, glows, tints, and perhaps even adding text.

In this project, we'll walk through the most common image correction techniques using Picasa, and we'll also take a look at some fun and interesting special effects. (If you need to install Picasa, see the instructions in Project 2.)

NOTE

In this project you'll see each major task as a standalone operation, starting with opening an image in Picasa and ending with an optional export step to make a copy of your picture. That's for your convenience down the road, so that you can later look up a single procedure and not have to flip pages for additional instruction. As you work with images in Picasa, however, keep in mind that you can open an image once and do all your corrections in a single session.

Basic Image Adjustments

Sometimes it's the little things that make the difference between a nice snapshot and a great photo. The difference is often very subtle. The camera may have been at a slight angle when the photo was taken, or there might be excess background or foreground that distracts from the subject. By working with Picasa (or the software that came with your camera), you can *straighten* (correct the alignment of the shot) and *crop* (cut off parts of the photo) to improve *composition* (the content of the photo). Compare the two versions of the same photo shown in Figure 3.1. Above is the original snapshot. Below, straightening and cropping provide a dramatic improvement.

FIGURE 3.1

At the top you see the original shot. Below, a slight change of rotation and cropping of unnecessary empty space makes a big difference.

TIP

Remember that you can rotate a photo 90 degrees (from *landscape* orientation to *portrait* orientation) right in Picasa's Library, by using the curved-arrow buttons below the preview area.

Opening a Photo to Edit in Picasa

To open a photo in Picasa's image editor, you simply double-click it in the Library window (see Figure 3.2). Alternatively, you can

right-click the image in the lower-left Picture Tray and then select View and Edit from the context menu.

Your image automatically appears in Picasa's Basic Fixes tab. (The Tuning and Effects tabs are discussed later in this project.) Note in Figure 3.3 the Back to Library button in the upper left (which returns you to Picasa's main window) and the Export button in the lower-right corner (which enables you to save your edited photo).

FIGURE 3.2

To edit a photo in Picasa, you double-click the preview or right-click it in the Picture Tray.

FIGURE 3.3

You can return to browsing by clicking the Back to Library button or make a copy of your edited photo by clicking the Export button.

NOTE

Picasa always protects your original photo—it will never be overwritten or resaved. At any time, even years from now, you can return the image to its original state with Picasa's Undo command. To make a permanent copy of your edited image, you click the Export button in the lower-right corner of the Picasa window.

Cropping with Picasa

Cropping is much like taking a pair of digital scissors to a digital photo. Picasa also offers the capability of resizing images to a desired print size while cropping. Here's how you crop with Picasa:

1. **Start Picasa**—Get Picasa up and running through the Start menu, by double-clicking a shortcut on the Desktop, or through the Quick Launch area in the lower-right corner of your screen.

2. **Locate the photo and switch to the image editor**—In Picasa's Library, navigate to the folder or label that contains the image you want to edit and double-click that photo in the upper-right preview area. The Basic Fixes tab of the Picasa editing feature appears.

3. **Click the Crop button**—In the Basic Fixes tab, click the Crop button to open the window shown in Figure 3.4.

NOTE

Feel free to practice with the image shown here—you'll find a copy of it on the CD that came with this book, as CrestedButte01.jpg in the folder Practice Images. (Please keep in mind that the photos on the CD are for practice only.)

FIGURE 3.4

Notice that when you're cropping, most of Picasa's other features are unavailable.

4. **Select a size for your cropped image—** Because different print sizes have different aspect ratios (the relationship between width and height), Picasa provides you with some preset selections. Use the buttons shown to the left in Figure 3.4 to select a size for your final image (4×6, 5×7, 8×10). Selecting Manual enables you to crop the photo to a custom size.

5. **Drag to designate the crop area and click Apply—**Click in the preview area to the right and drag to create a *bounding box* that designates what part of the image will be retained after cropping. Figure 3.5 shows that Picasa uses shading to indicate what will be excluded by the cropping. After dragging, you can drag the four sides of the bounding box to resize it and you can click within the box and drag it to reposition it. Click the Apply button to accept the crop.

FIGURE 3.5
You click and drag to create the initial box and then reposition or resize as desired.

6. **(Optional) Save a copy or export a copy of your image**—Use the File, Save a Copy command (or the keyboard shortcut Ctrl+S) to add a duplicate of the image file to the same folder. Alternatively, click the Export button in the lower right to create a separate image file of the cropped photo. This is the copy you'll share with friends and family or use creatively in Project 4, "Cards, Calendars, and Other Creative Projects." In Figure 3.6, you can see that the Export to Folder window enables you to specify a location on your hard drive, resize the photo (if desired), and select a JPEG Image Quality setting.

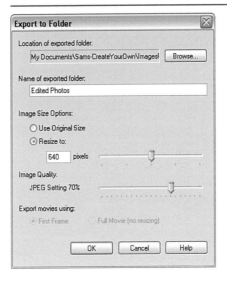

FIGURE 3.6
You can export a copy of a photo to share or save.

TIP

You might want to resize your images if, for example, they will be emailed to friends and family or posted on a website. Reducing the Image Quality setting produces a smaller file (which is easier to email), but at the cost of image quality. If you captured the photo using your camera's highest quality settings, an Image Quality setting of 60% is generally about as low as you want to go for an image that you might want to print. If you took the photo at any other camera setting, 90% might be a better choice.

Straightening with Picasa

Picasa offers a very elegant way to straighten photos—you simply drag a slider to align to a grid. Here's how you do it:

1. **Start Picasa**—Launch Picasa through the Start menu, by double-clicking a shortcut on the Desktop, or through the Quick Launch area in the lower-right corner of your screen.

TIP

Because Picasa records reversible changes to your photos rather than actually applying the changes, it's better to crop first and then straighten. However, in programs that really do edit the image itself, you should straighten first and then crop.

2. **Locate the photo and switch to the image editor**—In Picasa's Library, navigate to the folder or label that contains the image you want to edit and double-click that photo in the upper-right preview area.

Picasa's File menu includes the command Save a Copy (keyboard shortcut Ctrl+S). Using this command isn't quite the same as saving a file in, for example, Microsoft Word. After you've edited the image, perhaps cropped and reduced red eye, you can use Save a Copy to duplicate the photo with the current options, right in the same folder. (1 is added to the end of the filename the first time you save a copy, 2 is added the second time, and so on.) Using Save a Copy is a great way to experiment with your images; you can save different effects or crops as separate versions and then later select the variation that best suits your creative needs.

Picasa also offers the Export button and the File, Export Picture to Folder command (keyboard shortcut Ctrl+Shift+S). You can use this command to create a separate image file in a separate folder (which you can name). Of course, you can later move that exported image to any folder by using Windows Explorer. (Select the file in Picasa's Library and press Ctrl+Enter to open a Windows Explorer window with the file highlighted.) Exporting is a great way to make copies of your edited images to send to friends and family, as well as to use in projects with other programs.

So, what's the difference between Save a Copy and Export Picture to Folder? Remember that Picasa doesn't actually change your image when you edit it. Instead, the "changes" are saved with the original image file as commands that Picasa can later read and interpret. Save a Copy retains the original appearance of the file and the editing commands, while the Export Picture to Folder command actually applies the edits to a copy of the image file. You definitely need to use Export

continues

Picture to Folder when creating a copy of an edited image for use with another program—a program that likely can't read Picasa's editing instructions.

When exporting an image, you have the option of choosing the image dimensions (or retaining the original photo's pixel size) and a JPEG Quality setting (refer to Figure 3.6).

3. **Click the Straighten button**—After you click the Straighten button, a grid appears over the image in the preview area, giving you a visual reference for straightening the photo. As shown in Figure 3.7, you drag the slider back and forth until the content of the image aligns with the grid. (In this case, visual reference points include the grass, the upper bar of the goal, and the vertical trees.)

NOTE

You'll find a copy of the image shown here on the CD that came with this book, as soccer01.jpg in the folder Practice Images. (The photo was taken very low to the ground to provide an interesting perspective on a youth soccer game.)

4. **Accept the change**—Click the Apply button to actually straighten the image. (Alternatively, click the Cancel button if you change your mind.) Remember that Picasa doesn't permanently change the image file—you can use the Undo button at any time, even after quitting and restarting Picasa.

5. **(Optional) Save a copy or export a copy of your image**—Use the File, Save a Copy command (keyboard shortcut Ctrl+S) to add a duplicate of the image file to the same folder. Alternatively, click the Export button in the lower-right corner of the Picasa window to create a separate image file of the straightened photo. This is the copy you'll share with friends and family or use creatively in Project 4 of this book. (The Export to Folder window is shown earlier in this project, in Figure 3.6.)

FIGURE 3.7

Dragging the slider
rotates the image so
that you can
straighten it.

When you're editing an image in Picasa, you can click in the area directly below the preview on the words Make a Caption! Then you can add an image-specific label to the photo. The caption is visible only in Picasa and in advanced image editing software that can also see the EXIF metadata stored with the image file. In addition to a caption, metadata can include information about when and how the image was captured. Picasa's captions cannot be printed with the image.

Picasa's Red Eye Reduction

When a person looks directly at the camera when the flash fires and a picture is taken, the light generally reflects off the blood vessels at the back of the eye and appears in the image

as *red eye*. You can often prevent this spooky effect, shown in Figure 3.8, by using the Red Eye Reduction flash mode on your camera. (The various flash modes are explained in Project 1.) When you haven't used the Red Eye Reduction flash mode to prevent red eye, you can correct the photo later in Picasa:

1. **Start Picasa**—Open Picasa by using the Start menu, double-clicking a shortcut on the Desktop, or by using the Quick Launch area in the lower-right corner of your screen.

2. **Locate the photo and switch to the image editor**—Double-click the image in the preview area of Picasa's Library window to open it in the Basic Fixes tab.

3. **(Optional) Zoom in to check the eyes**—Before clicking the Redeye button, zoom in on the eyes to see if you actually need to fix red eye. Use Picasa's zoom slider, below

CROPPING TO CREATE PANORAMA PRINTS

A *panorama* is a long, wide photo (or tall and skinny photo) that shows a scene that doesn't fit in a single regular-size photo. True panoramas are created by aligning several sequential photos. You can create mock panoramas from a single photo with a little creative cropping.

Start with an appropriate photo, perhaps a shot of a distant horizon that has too much unwanted space at the top and/or bottom. Crop that photo to a size that's easily divisible by the size of your prints, using Picasa's Manual crop option. For example, if you have a printer that creates 4×6 prints, you might want to crop so that the final image can be pieced together at 12×6 inches (three 4×6 prints aligned vertically). The cropped image from Figure 3.1 is just such a picture. The red lines in the copy here show the eventual individual 4×6 prints, the *tiles* with which the panorama will be pieced together:

continues on page 58

the preview area, as shown in Figure 3.8. (You can also click in the smaller preview to the lower right and drag the visible area around the image to change your view.)

NOTE

Feel free to practice with the image used in this section. A copy of it is on this book's CD, as RedEye.jpg, in the folder Practice Images. (Please keep in mind that the photos on the CD are for practice only.)

4. **Click the Redeye button and drag over the eyes**—When you use the Redeye feature, Picasa zooms you back out to see the whole image. Click in the image and drag a small box around one of the eyes (as shown in Figure 3.9) and repeat for the other eye (or eyes, when correcting red eye in a group photo). Click the Apply button when you're done.

5. **(Optional) Zoom in again and check Picasa's work**—As you see is Figure 3.10, Picasa reduces red eye by darkening and slightly reducing the saturation of the pupil.

6. **(Optional) Save a copy or export a copy of your image**—Use the File, Save a Copy command (keyboard shortcut Ctrl+S) to add a duplicate of the image file to the same folder. Alternatively, click the Export button in the lower-right corner of the Picasa window to create a separate image file of the corrected photo. This is the copy you'll share with friends and family or use creatively in Project 4 of this book. (The Export to Folder window is shown earlier in this project, in Figure 3.6.)

FIGURE 3.8

You can zoom in as close as 400% in Picasa.

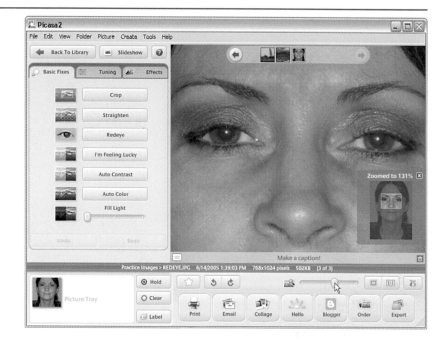

FIGURE 3.9

Drag a small box over each eye to make the red eye correction.

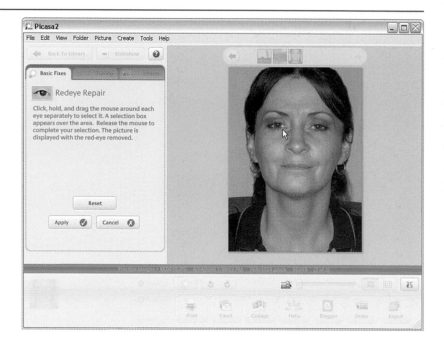

After your initial crop, return to Picasa's Crop feature and create the first of your tiles, the individual sections of the panorama. For example, you can use the 4×6 option and click the Rotate button to produce a vertical (portrait) orientation for the crop:

After using the Export button to create a copy of the file, you can click the Undo Crop button and then return to the Crop feature and create the remaining panels of your panorama:

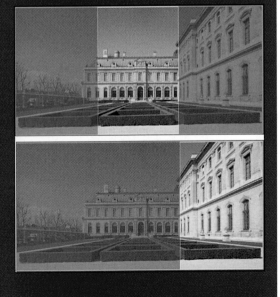

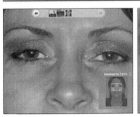
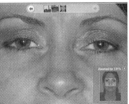

FIGURE 3.10
Picasa reduces red eye (but generally doesn't totally eliminate the problem).

TIP

Your camera probably has a Red Eye Reduction mode for the flash. If you've used it, you've noticed that there's a half-second or so between when you press the shutter button and when the photo is actually taken. That "shutter lag" helps prevent red eye, but it can also cause you to lose a great shot if the subject moves between the pre-flash and the actual shutter release. When your subject is likely to be in motion (rather than posing for a portrait or group photo), use Forced Flash mode rather than Red Eye Reduction mode and correct any red eye later in Picasa. (See the section "Your Camera's Flash Modes" in Project 1 for a refresher on using your camera's various flash modes.)

Improving Color and Lighting with Picasa

If your camera is working properly and *if* your printer is working properly, you *probably* don't need to make any color or lighting adjustments in Picasa (or other photo management software). *However*, there may be times when you need to work on the basic appearance of

your photos. When those situations arise, Picasa offers a couple of ways to fix things: the automatic way and the "in control" way.

Picasa's Automated Color and Lighting Repairs

Picasa's Basic Fixes tab offers three buttons and one slider to help you improve the color and lighting in your photos (see Figure 3.11).

Here's what each of the four features does for your photo:

▶ **I'm Feeling Lucky**—When you click the I'm Feeling Lucky button, Picasa analyzes and adjusts your image, deciding what should be "black" and "white" and trying to determine whether the image needs a color adjustment. It never hurts to click this button; you can always reverse the procedure if you don't like the result by clicking the Undo button.

▶ **Auto Contrast**—When you click Auto Contrast, Picasa finds the darkest part of your image and makes sure that it's black, then finds the lightest area and makes it white. The rest of the image is then spread evenly between black and white. Auto Contrast can give your photos a little "pop" to up their appearance. Compare the "before" and "after" Auto Contrast shots in Figure 3.12.

▶ **Auto Color**—If your photo has a general *color cast*—that is, an unwanted tilt toward orange or blue—the Auto Color button might be able to help. In Figure 3.13, you see that Auto Color has done a fairly decent job of eliminating the too-orange look of the holiday lights, neutralizing the color of the surrounding ice.

You need to export each image. After printing, you can put together your oversized panorama by having the prints mounted or simply by using tape (on the back of the images, of course). Compare the printed tiles of the panorama with the original image and the cropped image (both printed at 4×6):

You can, of course, use this technique to create an oversized image with just about as many tiles as you want. However, keep in mind that your image quality will eventually drop off if you start creating a final image that's *too* large.

FIGURE 3.11

Double-clicking a photo in the Library opens the Basic Fixes tab.

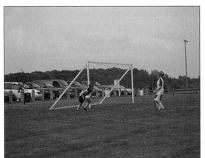 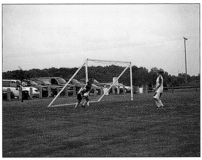

FIGURE 3.12

On the left, the original image. On the right, the result after clicking Auto Contrast.

FIGURE 3.13

Picasa's Auto Color feature neutralizes the color of a photo.

TIP

Take another look at the two images in Figure 3.13. In all honesty, I kind of like the nice warm glow of the original better that the colder look on the right. Sometimes it's best to *not* "correct" a photo.

FIGURE 3.14

You can use the Fill Light slider to produce an overall brighter picture.

▶ **Fill Light**—If your image is generally dark, or at least darker than you want it to be, you can use the Fill Light slider to brighten things up. As you see in Figure 3.14, this adjustment does a very good job.

Remember that you can use Picasa's automated adjustment features in combination. In Figure 3.15, you see the result of using Auto Contrast, Auto Color, and the Fill Light slider. Compare this version with the image on the left (the original) in Figure 3.14.

FIGURE 3.15

You can use the auto adjustments together to improve a photo.

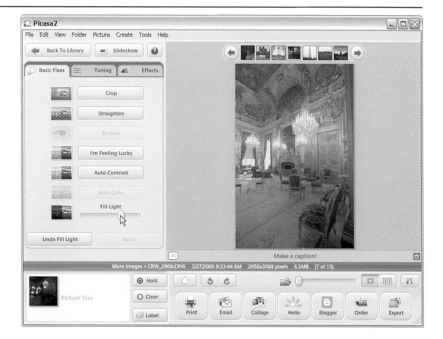

Picasa's Advanced Color and Lighting Capabilities

While the automated adjustments in Picasa's Basic Fixes tab do a reasonable job on many photos that require *some* improvement, the Tuning tab holds the key to control over your images. Not only can you use the Tuning tab to improve the general appearance of an image, but you can use it to create dramatic lighting effects, such as that shown in Figure 3.16.

Here's a look at the various controls in Picasa's Tuning tab:

▶ **Fill Light**—Just as in the Basic Fixes tab, the Fill Light slider in the Tuning tab enables you to generally lighten an image.

▶ **Highlights**—You use the Highlights slider to brighten the lighter areas of an image.

▶ **Shadows**—The Shadows slider lets you darken an image's shadows.

TIP

Your camera likely offers (buried deep in a menu) the opportunity to set a specific *white balance*. Consider white balance to be an adjustment to compensate for the type of lighting available when you take the photo: daylight, shade, fluorescent, incandescent, and so on. Your camera also offers Auto for white balance. Generally speaking, you leave the camera set to Auto. If you *must* shoot without flash under specific lighting circumstances, you might want to set your white balance manually—but remember to change it back to Auto afterward so you won't need to color correct images taken later!

▶ **Color Temperature**—You use the Color Temperature slider to remove a color cast from an image. You drag to the left to

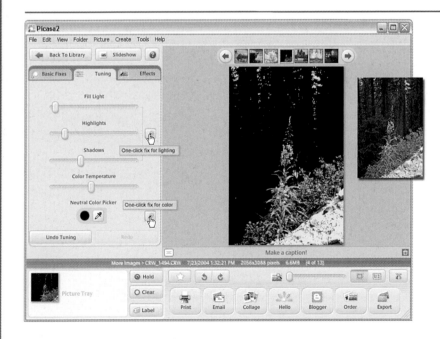

FIGURE 3.16

Darkening the shadows and lightening the highlights lets the subject of the image stand out from it surroundings. (The original is shown to the right.)

make the image less orange and to the right to make the image less blue.

- ▶ **Neutral Color Picker**—You can click the eyedropper icon to select the Neutral Color Picker tool, and then you can click once in your image on something that should be light gray (not something that *is* gray, but something that *should be* gray). Picasa automatically balances the color in the image to remove a color cast. (This is an automated way of correcting a color cast instead of using the Color Temperature slider.)

- ▶ **One-click fix for lighting**—You can click the button to the right of the Highlights slider to have Picasa automatically adjust the lighting in a photo.

- ▶ **One-click fix for color**—You can click the button to the right of the Neutral Color Picker to have Picasa automatically adjust the color in a photo.

TIP

For most images, you won't find *that* much difference between using the Basic Fixes tab's Auto Contrast and Auto Color and using the Tuning tab's one-click fixes. The one-click fixes tend to leave the image a bit *warmer* (more orange) and do a slightly better job of retaining a range of color in an image. Is it worth switching to the Tuning tab and using one-click fixes instead of the auto buttons? Yes—even when you're in a hurry, take an extra second to click the Tuning tab and apply the one-click fixes rather than use the Auto Contrast and Auto Color buttons.

WHAT IS A HISTOGRAM?

Picasa (and many other programs) can show you a graph that displays a mathematical representation of the appearance of an image. This graph, called a *histogram*, shows the distribution of *pixels* (the little squares of color of which a digital photo is created) at various brightness levels. The histogram displays the *tonality* (lightness, brightness/darkness) of your image.

In Picasa, you can show/hide the histogram (and camera info) with the propeller beanie button to the lower-right of the preview area:

So when should you use the histogram? When working in the Tuning tab, you might want to keep an eye on the histogram for three things:

- ▶ **Loss of detail in the highlights**—As you drag the Fill Light or Highlights slider, it may look like the histogram is disappearing off the right edge of the graph. That indicates that you're losing detail in the image's highlights—too many pixels are becoming pure white.

continues

▸ Loss of detail in the shadows—While adjusting the Shadows slider, you might see the histogram disappearing off to the left. That indicates that you are losing detail in the shadows of your image as too many pixels are forced to pure black. (That's not always bad—take another look at Figure 3.16.)

▸ Posterization—As you drag the Temperature slider, watch for gaps developing in the histogram:

This shows posterization—pixels of similar color being forced to a single color. Posterization changes smooth, gradual changes in color into blocky bands of different color. It's often most evident in highlights and shadows in a photo.

Sharpening and Applying Special Effects

Picasa's Effects tab offers a dozen special effects you can use to give your photos a custom appearance (see Figure 3.17). (And, like all other changes you make to images in Picasa, these changes are later reversible.) As you explore the Effects tab, remember that the effects can be combined and that Picasa's Edit menu includes the commands Copy All Effects and Paste All Effects so that you can easily duplicate your work on multiple images.

Sharpening with Picasa: How Much Is Enough?

Just about any digital photograph can benefit from at least a little sharpening. *Sharpening* is the process of emphasizing tiny edge details, making the photo appear to be more sharply focused. You can apply Picasa's Sharpen effect multiple times by simply clicking the button again. However, as you see in Figure 3.18, too much sharpening can produce unwanted emphasis on miniscule detail in the image. Figure 3.18 shows the original (top left), sharpened once (top right), sharpened twice (bottom left), and a close-up of triple sharpening (lower right).

TIP

Always zoom in to 50% or 100% when using the Sharpen effect so that you have a better idea of what's happening to your photo.

FIGURE 3.17

You can sharpen details, add film grain, or produce special color and lighting effects in Picasa.

FIGURE 3.18

Clicking the Sharpen button more than twice can produce unsightly "noise" in the image (bottom right).

Creating Old-Time Sepia Images

The Sepia effect produces a tinted image reminiscent of photos from long ago. In Figure 3.19, the original is shown to the right.

> **TIP**
>
> As you can see in Figure 3.19, Sepia also reduces the contrast in your image. After you use the Sepia effect, click the Tuning tab and give the Shadows slider a nudge.

Prematurely Gray: Using the B&W Effect

Another one-click effect (there are no sliders to adjust), Picasa's B&W effect simply removes the color from an image, leaving you with what appears to be a black-and-white photo. Remember that "B&W" actually means, in this case, "grayscale." There are *lots* of shades of gray, not just black and white. (You can see a sample of the filter to the left in Figure 3.17.)

> **TIP**
>
> After applying the B&W effect, click the Tuning tab and drag the Shadows and Highlights sliders a little to the right to improve the contrast in the image.

Improving Skin Tones with Warmify

Picasa's Warmify effect adds a slight orange tint to the image to make skin tones look better. Skip the Warmify effect completely—you have more control in the Tuning tab when you drag the Color Temperature slider to the right.

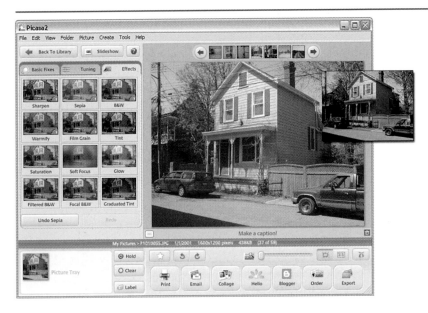

FIGURE 3.19

Sepia is a one-click effect—there are no options.

Getting the Nondigital Look with Film Grain

Photographic film has *grain* (texture) that digital photos don't have. Picasa's Film Grain effect simulates film grain. Unfortunately, as you see in Figure 3.20, it adds a *lot* of grain.

Using the Tint Effect

The Tint effect is actually a two-step process: picking a color and adjusting a slider. After clicking the Tint button, you must pick a color. You click the Pick Color button (shown in Figure 3.21) to open the color picker. You can click any of the preselected patches of color or move the eyedropper tool through the color picker to preview new colors. When you see a color you like, click the mouse button to select the color and return to the main Tint window. After selecting a color, you can use the Color Preservation slider to restore some of the image's original color, if desired.

Boosting Color with the Saturation Effect

If the colors in your photo could stand a little brightening up, head for the Saturation effect. You drag the slider to the right to increase the saturation of colors. As you see from the blue color creeping into the purple blooms in Figure 3.22, a large increase can result in some color shifts.

FIGURE 3.20

Using Picasa's Film Grain effect adds a lot of texture to images.

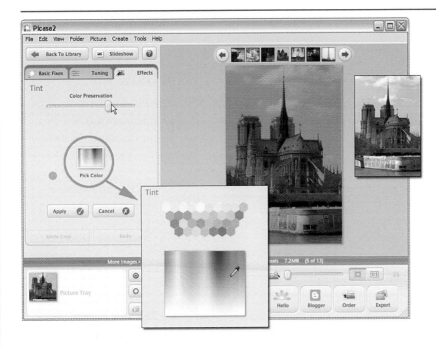

FIGURE 3.21

You can select a color and, if you would like, use the Color Preservation slider to reduce the effect. The original photo is shown to the right.

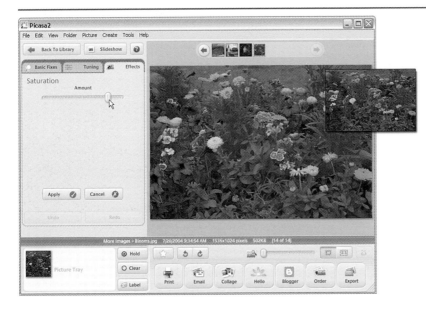

FIGURE 3.22

The original image is shown to the right for comparison.

Achieving Dreamy Effects with Soft Focus

The Soft Focus effect creates a circular area that remains properly focused and then gradually blurs the rest of the image. You control the center of the focused area by dragging a crosshair target symbol in the preview (see Figure 3.23) and then you adjust sliders to determine the extent of the blurring, both in

distance from the crosshair (size) and in amount.

Controlling the Glow Effect

Picasa's Glow effect spreads a soft blur over the brightest areas of a photo. Glow has a couple sliders to help you control the effect. You determine the brightness of the light-colored glow by using the Intensity slider and how far the glow will spread by using the Radius slider. (You can see a sample of the Glow effect to the left in Figure 3.17.)

Understanding the Filtered B&W Effect

Picasa's Filtered B&W effect simulates the look you would get if you shot your picture using black-and-white film with a colored filter over the lens. The filter screens out certain colors of

FIGURE 3.23

The crosshair symbol designates the center of the focused area.

light, changing the contrast in the final grayscale (B&W) photo.

When you click the Filtered B&W effect in Picasa's Effects tab, you see the same Pick Color button as in the Tint effect window. Clicking that button opens the color picker. Keeping an eye on the preview area, you can click any of the preset colors or move the eyedropper tool through the upper part of the color picker until you see the best contrast in your B&W preview; then you click the mouse button. The color of filter you select can have a substantial impact on the contrast in the final image, so it makes sense to try a number of colors.

> **TIP**
>
> **If you don't have an inkjet printer that's designed to produce grayscale (black and white), you can take such images to a local photo lab for prints.**

Controlling Grayscale with Focal B&W

The Focal B&W effect creates a circle in the photo that retains the original color and converts everything outside that circle to grayscale (black and white). You control the diameter of the circle with the Size slider and the fuzziness of the edges with the Sharpness slider (see Figure 3.24). You designate the center of the color area by dragging the crosshair symbol.

Applying a Gradient Filter with Graduated Tint

Picasa's Graduated Tint effect adds an overlay that fades from a color you designate to transparent. After you open the Graduated Tint effect, you can click the Pick Color button to open the color picker. You select a color by

FIGURE 3.24

The crosshair is the center of the color area, and Size and Sharpness control the diameter and fuzziness of the color area.

clicking. (As you move the cursor through the color picker, the preview is updated to show how the color will look with your photo.) After selecting a color, you can use the Feather and Shade sliders (see Figure 3.25) to determine the abruptness of the transition and the darkness of the color. Generally speaking, a larger Feather setting is more effective; a smaller Feather setting creates too sharp a line between "color" and "not." You can use Graduated Tint

very effectively with the Sepia effect as well as any of the B&W effects.

TIP

Remember that you can use the rotate buttons to the right of the Hold button while working with the Graduated Tint effect to alter the angle at which the gradient is applied.

FIGURE 3.25

The larger the Feather setting, the more gradual the transition.

CHAPTER 4

Cards, Calendars, and Other Creative Projects

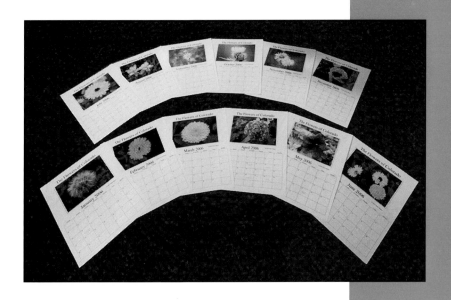

Photos are great to have around. Some photos remind us of places, times, and people we love. Others are simply nice to look at. Photo albums and framed enlargements are wonderful, but you can do much more with your digital photos. By using your own digital photos and programs you probably already have installed on your computer, you can create fun, informative, decorative, and even elegant projects. Adding photos to Microsoft Word and PowerPoint documents is simple (and you can even use Microsoft Works with your digital photos).

By using Microsoft Word, your digital photos, and an inkjet printer, it's a piece of cake to create a variety of personalized printed materials. The basic technique is this: Open a document. Insert your photo(s). Add text. Save. Print.

In this project, I walk you through a few creative exercises to show you the basic techniques, which will give you a foundation from which to expand and explore on your own.

> **NOTE**
>
> You'll want to print what you create in these exercises on heavyweight matte paper rather than too-thin plain paper or expensive glossy paper.

Creating a Greeting Card

Commercial greeting cards come in a wide variety, from mushy to merry, cheery to charming, heartfelt to hilarious. Hallmark, Zelda Wisdom, the Far Side, and other brands seem to fill every niche imaginable. So why would you want to create your own greeting card? Let's start with price—for a few pennies' worth of ink and paper and just a couple minutes, you save a couple bucks on the card. By doing it yourself, you also save a trip to the store and the (seemingly) endless search through the racks for the *perfect* card. One other benefit of doing it yourself is that you can create a completely customized, personal card for the recipient. (And just think of the compliments you'll receive!)

Setting Up Your Template

You can use any word processing program or illustration program to create custom greeting cards. In this exercise, I demonstrate using Microsoft Word:

1. **Open and orient a new document**—After opening a new document with the File, New command, select File, Page Setup to open the Page Setup dialog box. In the Margins tab, select Landscape as the orientation and set all the margins to 0.5", as shown to the left in Figure 4.1. Next, click the Paper tab and verify that your paper size is set to 11" wide and 8.5" tall. Click OK.

> **NOTE**
>
> On the CD that accompanies this book, you'll find a couple greeting card templates I prepared for you. But, of course, that's no reason not to complete this short exercise, which teaches some basic concepts about using your digital photos with a word processing program.

FIGURE 4.1

You use the Page Setup dialog box to create a landscape-oriented document.

2. **Divide the page with Columns**—Open the Columns dialog box (shown in Figure 4.2) with the menu command Format, Columns. Click Two in the Presets area and set Spacing to 1". (When the card is folded in half, that leaves a half-inch margin along the inside edge, which matches your margins for the outer edge and the top and bottom.) Leave the Width set to 4.5". Click OK.

3. **Add a column break**—Use the menu command Insert, Break and then select Column Break. The cursor moves to the top of the second column.

4. **Add the inside page**—While you don't have to do so at this point, I always like to add the inside page right away. Use the menu command Insert, Break and then select Page Break. Go back to the Insert, Break command and select Column Break so that all four columns are readily available. This is also a good time to use the Edit, Select All command and then click the Center Alignment button or use the Format, Paragraph command to select Center as the alignment option.

FIGURE 4.2

A pair of columns separates the page into front and back.

Remember that you'll be working primarily in the right-hand column on both pages. Figure 4.3 shows the basic layout.

5. **Save your setup**—Use Word's File, Save As command. In the Save as Type field select Document Template (*.dot). For a filename choose **BlankCard.dot** or any other recognizable name. Click the Save button.

FIGURE 4.3

When the card is folded, the right side of the first page becomes the front of the card.

(Saving as a template lets you reuse the basic layout any time in the future.)

TIP

I suggest that you create a new folder inside your My Documents folder in which to save your custom templates. That way, the templates won't get lost should you ever need to (gasp!) reinstall Word.

Creating Your Card

Now that you have a basic layout, it's time to add a photo and custom text to your card:

1. **Add a photo**—Move the cursor to the right-hand column on the first page, the column that will be the front of the card. Use the Insert, Picture, From File command to open the Insert Picture dialog (see Figure 4.4). Navigate to and select your photo and then click the Insert button.

2. **Resize your photo**—After you insert your photo into the document, click directly on it. You see a *bounding box* around it—that is, a frame with *anchor points* in each corner and the middle of each side. Click and drag the lower-right anchor point to resize the photo (see Figure 4.5). If you'll be adding text to the front of the card, be sure to leave some extra space.

3. **(Optional) Add text to the front of the card**—Use the Format toolbar above your document to select a font and a size for your type. If you would like to add text above the photo, press the left arrow key then press the Enter key a couple times and then move the cursor to the top of the column by using the up arrow key.

 If you would like to add text below the photo (as shown in Figure 4.6), resize the photo and then press the right arrow key and press Enter a couple times.

TIP

Don't forget about Word's text effects! Select the text and then use the Format, Font command to open the dialog box. You can select from among such effects as Shadow, Outline, Emboss, Engrave, and Small Caps.

FIGURE 4.4

Microsoft Word can work with most graphic file formats, including the JPEG format that is likely created by your digital camera.

FIGURE 4.5

Click and drag an anchor point to resize the photo.

FIGURE 4.6

You can use your keyboard's arrow keys and the Enter key to position the cursor to add text above or below the photo.

4. **Add the primary inside text**—Press the down arrow key a couple times to move to the right-hand column on the second page of the card. You probably want to press the Enter key a couple times to move down the page some, and you might want to select Format, Paragraph to open the Paragraph dialog box, where you can adjust the line spacing (as shown in Figure 4.7).

5. **(Optional) Add a personal message**—You can further customize your card with a customized message for the recipient (or leave the card in a more generic format so that you can print multiple copies for various occasions). Because my handwriting is virtually unreadable, I like to add the message right in Word, using a different font and font size (see Figure 4.8).

6. **(Optional) Add a credit/copyright notice**—Down near the bottom on the back of commercial greeting cards, you find copyright and credit information. You, too, can add that sort of info. Move to the left-hand column of the first page, press Enter a number of times to move down the page, and add the information in small type (see Figure 4.9). (Keep in mind that you shouldn't add a copyright notice to the card unless both the photo and text are original and yours.)

Printing Your Card

Your gorgeous greeting card is now ready to print and mail (which is a good thing because your computer probably doesn't fit in the envelope).

FIGURE 4.7

You can customize the appearance of the text with the Formatting toolbar and the Paragraph dialog box.

FIGURE 4.8

A cursive or script font is great for adding a personal message to your card.

NOTE

For this project you'll need to print on heavy-weight two-sided paper. (Look for the terms *double-sided* and *coated on two sides*.) Remember, too, that you can purchase special papers for specific projects. Avery Dennison Office Products, for example, offers dozens of blank Avery cards, brochures, and labels, for both inkjet and laser printers. Blank cards are also available from Hallmark.

1. **Print page 2 of 2 first**—The inside of the card has less on it, typically just some black text, so print that side of the paper first—there's less chance of it being smeared or damaged when you print the other side.

FANCY TEXT WITH FUN FONTS

In this exercise I use the font named *French Script MT* (as you can see in Figure 4.6). This font may or may not be available on your computer. There are many places on the Web where you can download free fonts. I must warn you that some of them are problematic and can cause instability. In addition, you shouldn't download any *bitmap* fonts, no matter how cool they look—stick with PostScript fonts (TrueType, PostScript Type 1, and OpenType). Here are some of my favorite sources for free fonts:

www.1001fonts.com

www.abstractfonts.com

www.acidfonts.com

www.astigmatic.com

www.chank.com

www.coolarchive.com

www.larabiefonts.com

www.paratype.com

www.bvfonts.com

You can purchase collections of commercial fonts from a wide variety of sources. Here are my two favorites:

www.adobe.com/type/

www.fonts.com

To make your new fonts available to Word and other programs on your computer, you select Start, Control Panel and double-click Fonts. Then you use the File, Install New Font command.

FIGURE 4.9

The back credits should use small text.

2. **Print the outside of the card**—Let the ink on the inside of the card dry for a couple minutes (you want it *completely* dry before you print the second side). Reload the paper into the printer's paper feeder. Remember when moving the paper from the output tray back to the input tray that the left edge remains on the left side— flip the paper end over end, not sideways.

TIP

If your printer offers the option, select Second Side as the paper choice in the Print dialog box when printing the flip side of the card. And print page 2 (the inside) first. Typically your inner page will have less ink and therefore not be as delicate as it passes through the printer the second time.

3. **Let dry (thoroughly), then fold**—After the ink is completely dry (go do something else for 10 minutes or so), gently curve the paper to align the edges, then carefully crease the folded edge. There it is, your custom greeting card! (The demonstration card created in this exercise is shown in Figure 4.10.)

By the way, after you fold your 8.5×11 card in half, you use a size A9 envelope (5.75×8.75 inches), commonly called (of all things!) a "greeting card envelope." You can find these envelopes at any office supply store.

FIGURE 4.10
Here's what my finished product looks like.

Making Individualized Invitations

In this exercise, I show you how to use a digital photo in an invitation, which you can then customize (if desired) for each person on the guest list.

PICASA'S COLLAGE FEATURE

Picasa includes a rather interesting feature that can be used very effectively to create a montage or collage of several photos. In Picasa, you select a number of images, click the Hold button to retain them in Picasa's Picture Tray area (in the lower left), and then click the Collage button.

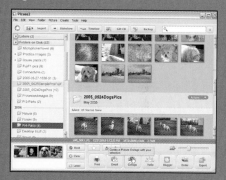

Next, you select the type of pattern you want to create. Picture Pile is best with at least 3 pictures. Picture Grid can use 4, 9, or 16 pictures (it duplicates some images if you use another number of images). Using Multi-Exposure with more than 2 photos generally produces an artistic-looking mess. (Contact Sheet adds the folder name, so it's not a good choice for creating greeting cards and calendars.)

You can choose to use one of the selected photos as a background image for Picture Pile, or you can select a plain white, gray, or black background. Remember, too, that in Picture Pile and Picture Grid, you can drag photos in the preview area to rearrange them.

Creating the Basic Invitation

To make individual invitations, you should open Microsoft Word and then follow these steps:

1. **Open a new document and set the margins**—Use Word's File, New command to open a letter size (8.5 inches by 11 inches) document. Next select File, Page Setup and set each of the four margins to 0.5" to maximize the amount of space for the invitations.

2. **Add a table**—You don't need a full sheet of paper for each invitation, so you can put four of them on each page and cut them apart after printing. (You may hear the term *4-up* used for pages that contain four copies of the same item.) Use Word's menu command Table, Insert, Table and add a table with two columns and two rows. Click the OK button and then position the cursor over the lower-right corner of the table and drag downward to expand the table, filling the area within your margins (see Figure 4.11). Now use the command Edit, Select All (Ctrl+A), and then click the Center Alignment button in the Formatting toolbar. (This ensures that everything in each of the four cells of the table is center-aligned.)

3. **Insert your content**—Typethe opening text for your invitation in the first cell of the table. Use the command Insert, Picture, From File to add a digital photo. Then type any additional text. One sample layout is shown in Figure 4.12. (The fonts used are Uncle Stinky and Mister Frisky, both from www.chank.com.)

4. **Duplicate the invitation**—Hold down the mouse button and drag the cursor to select the text and photo (as shown to the left in

FIGURE 4.11

You expand the table to fill (but not go past) the area within the margins.

FIGURE 4.12

You add text, insert a photo, and add some more text.

FIGURE 4.13

When selected, a photo's colors are inverted, as is the text.

Figure 4.13), then use the Edit, Copy command (Ctrl+C). Move the cursor to the top of the second cell of the table, click the mouse button, and use the Edit, Paste command (Ctrl+V). Use the Edit, Paste command (Ctrl+V) in the other two cells so that you have four invitations on the page (as shown to the right in Figure 4.13).

Individualize and Print Each Invitation

When your basic invitation is set up, you can—if desired—create a second side for additional info, and even add each guest's name to personalize the invitations:

1. **(Optional) Add info for the flip side—** Add a second page, add a table to that page as you did for the first side. Then add the information you want printed on the back. You might, for example, add time and an address, whether an RSVP is expected, and other such information.

TIP

If you're doing two-sided invitations, print the back side, the "un-personalized" side, first. You'll want to print all the page 2's before you continue on with the next step.

2. **(Optional) Personalize the invitations and print—**As you see in Figures 4.12 and 4.13, I used the generic "(name)" on the front side of the invitation. You've no doubt also typed up your guest list in Word, right? Open that document and position it alongside your invitation. Select and copy the first name from the list, switch to the invitation, and paste the name (see Figure 4.14). Switch back to the list, select the second name, copy it, and paste it into the invite. Repeat for each of the four invitations on the page. Print the front side of the invitations.

PET PICTURES FOR EMERGENCIES

We hate to even think about it, but it's one of life's emergencies for which you can prepare. The thought of a beloved pet running away, getting lost, or even being stolen can be a nightmare. Be prepared! Make sure you have the photos you need to create an effective Lost Pet poster.

What constitutes a good Lost Pet poster? First and foremost, the poster needs to identify the pet. A description is good, but photos are better. And not just *any* photos. You need pics that help people identify your pet. And not just one photo, but several. Compare the two photos here. Which one do *you* think gives a better idea of the dog's size and overall appearance?

Of course there's no reason *both* of those pictures couldn't be on the poster, right? You'll also want to have photos of any readily identifiable markings on the pet. Hugo, for example, is a cancer patient with areas of fur that never grew back after surgery. Including a description and close-up of that unique physical attribute helps make him more identifiable.

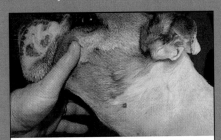

Areas of Hugo's neck and tummy were shaved for surgery and the hair has not grown back completely. He also has small bald spots at various locations on his sides.

Hey, Greg! I
Join us this Fourth of July for

FIGURE 4.14

You can insert each person's name and print individualized invitations.

As soon as the first page starts printing, copy and paste (one at a time) the next four names on your list. Print. Repeat until you've printed one invitation for each name on the list. (And make sure that each personalized invitation goes into the right envelope or gets handed to the correct person.)

TIP

It doesn't hurt to print a few extra invitations with *no* name—just in case you bump into someone who should be invited but wasn't on your original list.

3. **Separate the individual invitations—** Carefully cut the individual invitations apart.

TIP

If you will be printing custom invitations, cards, and other such items on standard heavyweight matte paper rather than on the more-expensive precut cards, consider purchasing an inexpensive paper trimmer ($30–$50 at an office supply store). Such cutters come in two basic styles: models with a long cutter arm that pivots downward and those with a rotary blade that slides along the arm. Either style can cut several sheets of card stock at once, with very professional-looking results.

Creating Custom Calendars for the Coming Year

Making a 12-month calendar is a great way to show off a dozen of your favorite photos—and to share them with friends, family, colleagues, and even customers. All you need are some photos, Picasa (on this book's CD or free from www.picasa.com), Microsoft Word (or a comparable program), and an inkjet printer. You can use the template I've prepared for you (also on the CD) or create your own.

Preparing Your Photos in Picasa

The first task when creating a calendar is to select and prepare the photos:

1. **Pick your pictures**—Choose a dozen pictures to use in the calendar. Family

What else should you include on a Lost Pet poster? Consider this information:

- Last seen (location and date/time)
- Whether the pet was wearing a collar and any tags
- Favorite places
- Height, length, and weight
- How he/she behaves with strangers
- Whether the pet is treat-trained
- Contact information, including your phone number and address (If you have a cell phone, use that number so people can reach you while you're out searching.)
- Whether there is a reward offered

There's no need to prepare a Lost Pet poster in advance, but it's a very good idea to have the pictures available, just in case. If you have a puppy or kitten, make sure to take pictures often during those early rapid-growth months. (Right. As if you needed an excuse to take pictures of your new pet!)

Keep in mind that you can weather-proof a poster (Lost Pet, Yard Sale, Open House, just about any poster you need to hang outdoors) by putting it in a gallon-size plastic bag (open end downward) and taping (rather than stapling) it to hang it. Don't forget to take the posters down after your pet comes home or the event is over!

shots, pets, scenic vacation shots (seasonal, perhaps?), whatever photos you want to use. They don't have to have a theme, but a theme can make for a more interesting calendar.

2. **Crop each photo to 4×6**—One at a time, double-click each photo, click the Crop button, and crop the image to a landscape-oriented 4×6-inch size (see Figure 4.15).

3. **Export the photos to a folder**—Add the photos to Picasa's Picture Tray. (You don't need to click the Hold button unless the photos are in different folders or Labels.) Click the Export button (see Figure 4.16).

4. **Choose your Export options**—Specify a folder name and location. Retain the original size and use the highest Image Quality setting (as shown in Figure 4.17).

Customizing the Calendar

Now that your photos are ready, you can quit Picasa and switch to Microsoft Word. Then you follow these steps:

1. **Open the template**—Make sure this book's CD is in your computer's optical drive and then use Word's File, Open command. Navigate to the CD, select the file **2006CalendarTemplate.dot**, and then click Open.

2. **Save to your hard drive**—The template file is *read-only*, so you cannot make changes and save it back to the original location. (Not only can't you save directly to the book's CD, the file itself is read-only.) Choose a location on your hard drive and a name such as **PictureCalendar.doc** and save the calendar as a Microsoft Word Document (with the **.doc** file extension, not the template's **.dot** file extension).

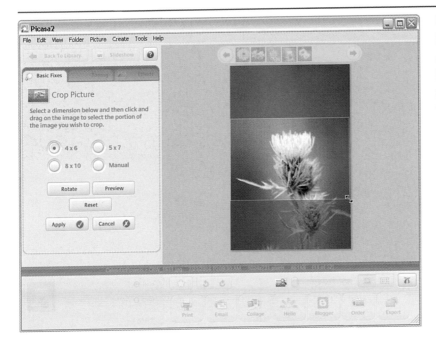

FIGURE 4.15

Even the portrait-oriented pictures should be cropped to a landscape 4×6 to work with this template.

FIGURE 4.16

If you have to switch among folders/Labels, click the Hold button to keep each photo in the Picture Tray before exporting.

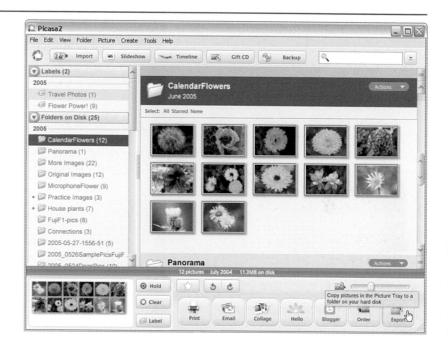

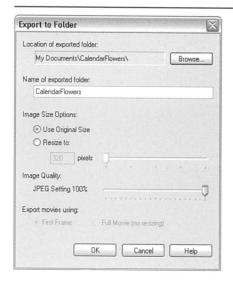

FIGURE 4.17

You already resized the images when cropping, and because this project is to print, you want to use the highest Image Quality setting.

TIP

Notice that I didn't leave an empty space between "Picture" and "Calendar" in the filename in step 2. It's a good habit to never use empty spaces or special symbols in filenames to avoid problems opening the files in the future. While Windows XP itself doesn't have a problem with empty spaces in filenames, some network servers and other computers might.

3. **Zoom out to view the whole page**—To get a feel for the project, take a look at the whole month of January. Use the View, Zoom command or select Whole Page from the Zoom menu in the Style and Formatting toolbar, as shown in Figure 4.18.

FIGURE 4.18

You can use the Zoom menu to easily change the view of your document.

4. **Make your plan**—You need to change three elements on each page (see Figure 4.19):

FIGURE 4.19

The red boxes indicate items that you customize.

▸ **Title**—You can use a single title, with the same title on every page. Alternatively, you might want to add a different title to each page, perhaps describing the photo.

▸ **Picture**—You add your own photos, exchanging them for the *place holder* image that's filling the space.

▸ **Copyright**—To the lower right of the image (to the right of the month name), you add your own name to the copyright. Or, if the images are not your own, you delete the copyright info.

5. **Customize the titles**—Start with January and work your way through to December. First triple-click (click three times very fast) in the title at the top to select the text. Then, with the text selected, type your own title. (The highlighted text is automatically deleted when you start typing.) Repeat on each of the other 11 pages. (If you're using the same title for each page, using

copy/paste makes sense.) Save your file by using the shortcut Ctrl+S.

inserting the image you have designated for each month. Save your work by using Ctrl+S.

TIP

You can change the font if you would like, but keep an eye on the *text flow*. If the bottom line of the calendar's grid disappears, you need to use a smaller font size to prevent the title from taking up too much room on the page.

NOTE

Make sure you click somewhere in the center of the placeholder image, not near the edge. You want to select the image itself, not the box surrounding the image.

6. **Add your photos**—Return to January. Click once on the placeholder image to select it. (The bounding box appears around the outside.) Choose Insert, Picture, From File. Navigate to and select your first photo, and then click the Insert button (see Figure 4.20). Repeat for each page of the calendar,

TIP

Remember that you can adjust the cropping of images in Word. You click the photo to select it and then choose Format, Picture.

FIGURE 4.20

You select and insert photos.

7. **Zoom in and change the copyright info**—Zoom to 100% so you can work with precision. Use the scrollbars at the bottom and right of the Word window to bring the copyright information into view. Drag over the words Your Name to highlight them (see Figure 4.21) and then type your own name. (If you do not own the copyright on the image, either add the copyright holder's name or select and delete the entire copyright notice.) Use the Page Down key on your keyboard to navigate month-to-month and change the copyright information on each page.

8. **(Optional) Add birthdays and anniversaries**—Navigate to the appropriate month and day, click to the right of the day's number, and press the Enter key twice. Type the occasion. You can format the font as you would like, perhaps using a different color and size. If you want your special dates to match the holidays already on the calendar, choose Format, Styles and Formatting. Select the text you added to the calendar and click the style named Holidays (see Figure 4.22). (This is a special style I created for this calendar. It's embedded in the template for your convenience.)

> **TIP**
>
> After typing your name the first time, you can simply select and copy it Then you can select Your Name and paste for the other 11 pages.

Printing and Binding Your Calendar

The final step prior to distributing your customized calendar is to make it a physical object rather than simply data in your computer:

FIGURE 4.21

You replace Your Name with, you guessed it, your name.

FIGURE 4.22

You can format your special days to match the holidays on the calendar.

1. **Print your calendar**—You can print this project on reasonably priced photo-quality inkjet paper rather than heavyweight paper. (I advise against printing on plain paper.) Photo-quality ("everyday") inkjet paper lends an elegant look and feel to the calendar, as well as a surface on which you can write with a ballpoint pen or a pencil. A sample calendar using this template is shown in Figure 4.23.

FIGURE 4.23

This printed monthly calendar was created using the template on this book's CD.

If you use PowerPoint, you're probably very familiar with clip art. A presentation without some graphic elements just doesn't seem, well, *right* anymore. But clip art has become "old hat" over the past several years and often seems amateurish.

Here's yet another great place to use digital photos. You can use digital photos you already have, or you can shoot images for specific purposes and slides in PowerPoint. Using PowerPoint's Picture toolbar (just like the Picture toolbar in Word) is a great way to prepare a photo for use as a background. A few clicks on the More Brightness button, perhaps a click or two on the More Contrast button, and there you have it—a custom background!

2. **(Optional) Fasten the pages**—A couple staples along the top edge will hold the pages together, but you might want to opt for something a little more elegant (especially if you're giving the calendars as gifts). Full-service copy stores, such as Kinko's, offer a variety of options (called *finishing services*), such as coil, comb, and wire binding.

Other Project Ideas

Now that you understand some of the basic techniques, let your imagination run wild. Here are some projects you might want to consider:

▶ **Customized change-of-address cards**— Moving? Make your own change-of-address cards—and include a photo of the new house! Use a postcard-sized layout for easy (and inexpensive) mailing.

▶ **Business/calling cards**—How about some business cards (or simple calling cards) that include your photo?

▶ **Recipe sheets**—Have some special recipes? Type them up and include photos of the finished dish. Print them out and collect them in a binder. Perhaps even share them with friends. For complex recipes, perhaps you could include some "in progress" photos, showing how to handle certain

steps in the recipe. Maybe even a photo that shows what exactly you mean by a *pinch* of oregano.

- **Take photos for your eBay sales**—Adding a photo to the item reportedly is great for sales! (Isolate the subject on a plain surface with a plain background for best results.)

- **T-shirts, coffee mugs, and more**— Purchase special "paper" for your inkjet printer to create your own t-shirts. Take your photos on CD (or the camera's card) to a local photo store to have them printed on coffee mugs, aprons, and other such products.

CHAPTER 5

Advanced Image Editing

In Project 3, "Taking the Next Step: Improving Your Pics," we explored ways to work with digital photos in Picasa, and in Project 4, "Cards, Calendars, and Other Creative Projects," we saw some of the editing capabilities in Microsoft PowerPoint and Word. As handy as those features are, they are but a drop in the ocean of photo manipulation.

Just about every incredible digital photo and special effect you've seen in magazines and advertising has been produced with the help of Adobe Photoshop. Photoshop is used by millions of professional and amateur photographers, graphic designers, illustrators, and commercial artists. It is found in studios, research facilities, hospitals and doctors' offices, crime labs, schools and universities, advertising offices, and Hollywood film studios, and it is used in countless ways by millions of people worldwide.

In this project, we'll take a look at the power of Photoshop and then explore a lower-cost, more user-friendly alternative, Adobe Photoshop Elements. Then, for the balance of the project, we'll take Elements for a test drive.

Photoshop: The Ultimate Image Editor

When it comes to digital images, there's *nothing* you can't accomplish in Photoshop. Some things are easier than others, of course, but when you can control the appearance of each individual pixel in the image, one at a time, you can make the image appear any way that you please. (Remember that a *pixel* is one of the tiny squares of color with which a digital image is formed.)

What Can Photoshop Do?

Photoshop provides the power to combine multiple photos into a single image. The picture shown in Figure 5.1, which I created for *The Photoshop World Dream Team Book,* Volume 1 (New Riders), includes a sky from Italy, mountains from Germany, trees from northern Michigan, and an outdoor stage from Ohio. (The female "model" is computer generated, using a program called Poser from Curious Labs.)

In addition to having the power to create imagined scenes, Photoshop is a workhorse in the photo studio. Consider, for example, the "before" and "after" shots in Figure 5.2.

Commercial artists, graphic designers, and illustrators use Photoshop to create many of the effects you see in advertising on a daily basis. Figure 5.3 shows a few examples of some of the text effects that are a snap in Photoshop.

What Makes Photoshop So Powerful?

One of the biggest differences between what you can do in Picasa and what you can accomplish with Photoshop is the capability of making selections. A *selection* isolates part of an image—that is, specific pixels in the image—so that you can manipulate just those pixels, leaving the rest of the image untouched. Photoshop also includes tools that let you paint right in the image, as if with a digital paint brush. You apply color by dragging a path with the mouse. I should mention, however, that most professionals who paint with Photoshop use a Wacom drawing tablet (see Figure 5.4), replacing the mouse with a pen-like stylus for greater control.

FIGURE 5.1

Photoshop enables you to combine multiple elements into a single image.

FIGURE 5.2

Beauty is certainly in the eye of the beholder. But it's also under the control of Photoshop.

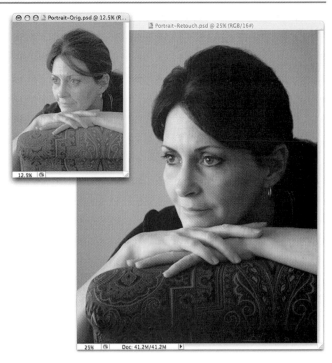

FIGURE 5.3

Text with photos inside, 3D effects, and the common drop shadow are all easy to produce using Photoshop.

FIGURE 5.4

Using a stylus with a Wacom tablet is more natural than "painting" by using a computer's mouse.

Brush-using tools in Photoshop can do much more than simply apply color. Various tools can, as you paint with a stylus or drag the mouse, duplicate other parts of the image (called *cloning*), selectively blur or sharpen, and replicate the non-digital photographer's darkroom techniques of *dodging* (lightening areas of the image) and *burning* (darkening specific areas).

Perhaps the most powerful of all Photoshop's features, when it comes to creativity, is often taken for granted. When working in Photoshop, you work with *layers* in the image. Each layer contains its own pixels, which can be opaque, translucent, or transparent. Where pixels on an upper layer are opaque, they block from view pixels on lower layers. When upper-layer pixels are transparent, the lower-layer pixels are visible. Where the upper-layer pixels are translucent (because you use a lowered *opacity* or a specific *blending mode*), the upper-layer and lower-layer pixels interact.

Photoshop also offers *layer masks*, which you use to change the visibility of parts of a layer. Figure 5.5 shows a section of the image shown in Figure 5.1 to demonstrate how Photoshop's layers work.

To the right, in the thumbnails of the Layers palette, the checkerboard pattern indicates transparent areas. The black-and-white thumbnail to the right for the top-most layer is a *layer mask*, which controls the visibility of the pixels on the layer. The stage appears to be in front of the mountains, which appear to be in front of the sky, because of the order of the layers in the Layers palette.

The Affordable Alternative: Adobe Photoshop Elements

While Photoshop is an incredibly powerful tool, it's also a rather expensive piece of software ($599 list price for Photoshop CS2).

FIGURE 5.5

Referring to the Layers palette to the right, you can see the interaction of layers and layer masks.

DIGITALPHOTOGRAPHY.TV

Sign up for the cool newsletter, or check out the inspirational photo gallery at this site. Even if you're not an expert photographer, you'll be able to draw inspiration and ideas from this photographer's website (including closeups of flowers, a trip to Yosemite, and links to other art photography sites on the Web).

Photoshop has some pretty hefty hardware requirements, too. Running Photoshop on Windows XP requires a computer with an absolute minimum of 320MB of RAM (memory available to Photoshop while running) and at least 650MB of space on the hard drive. It also has a tremendous learning curve (that is, the amount of time and experience it takes to become proficient with the program). While books such as *Sams Teach Yourself Adobe Photoshop CS2 in 24 Hours* (Sams Publishing) and my own *Photoshop CS2 For Dummies* (Wiley) can help you learn Photoshop, it's still quite a job!

However, I'm happy to announce that a number of other programs fill the gap between Picasa's basic photo correction tools and Photoshop's incredible image manipulation capabilities. And they do so with a much lower price tag and a much easier learning curve. Perhaps the most powerful of the alternatives is based on Photoshop itself.

Adobe Photoshop Elements Features

Adobe Photoshop Elements, or simply "Elements," as it's known, has many of Photoshop's own tools and capabilities, in a more user-friendly package that includes Quick Fix and Auto Fix modes, which are not found in the professional version of Photoshop. And Elements costs a fraction of what you would spend on Photoshop ($99 on CD, $89 for download from Adobe.com).

Here are some of the other main features of Photoshop Elements:

▶ **Organizer**—The Organizer in Elements helps you streamline your photo storage with *stacks* (groups of similar pictures bundled together), with only one photo visible to reduce clutter. (We'll work with stacks later in this project.)

▶ **One-click fixes**—Quick Fix mode (see Figure 5.6) offers one-click buttons to fix most common lighting and color problems.

▶ **Editing and compositing**—You can take matters into your own hands by working with sliders and tools to customize the appearance of your images.

▶ **Slideshows**—The Slideshow feature in Elements enables you to not only organize photos into a sequential display but also to add music and narration.

▶ **VCDs for viewing on TV**—You can create CDs of your slideshows that can be viewed on any television that has a DVD player. (Great for group viewing and to send to people who don't have computers.)

▶ **Custom templates**—Elements includes step-by-step procedures for creating calendars (shown in Figure 5.7), greetings cards, and postcards. (And, indeed, using Elements is even simpler than using the templates on this book's CD!)

▶ **Picture Package**—You can save paper (and money) by printing multiple pictures on a single sheet of paper—several copies of the same photo in various sizes or a number of different photos.

▶ **Camera phone photo fixes**—By using Elements, you can fix photos taken with a camera phone quickly and easily. The step-by-step process takes those tiny little images and improves them to the point where you can actually print them as snapshots.

FIGURE 5.6

You can use the Smart Fix Auto button for a one-click adjustment of color and shadow/ highlight details.

FIGURE 5.7

You have lots of layouts available when creating calendars in Elements.

NOTE

Elements isn't the only program in the wide spectrum between Picasa and Photoshop. You'll find quite a few capable and user-friendly alternatives, including software from ArcSoft.com and Trevoli.com. However, Elements is the program that best balances the ease-of-use of basic programs with the incredible capabilities of Photoshop.

Learning Photoshop Elements

Adobe provides a number of online tutorials to help you learn the more powerful features of Photoshop Elements. Many of the creative projects are step-by-step and walk you through the process with full instructions. However, to take

full advantage of the power of Photoshop that's built into Elements, you need a little more help. A wide variety of books are available, including *Easy Adobe Photoshop Elements 3* and *Adobe Photoshop Elements 3 in a Snap* (both from Sams Publishing, see Figure 5.8).

Test Driving Adobe Photoshop Elements

One of the best ways to get a feel for a program such as Adobe Photoshop Elements, to decide whether it's a worthy investment, is to actually work with the software. You can download the latest trial version of Elements from the Adobe.com website, or you can install

FIGURE 5.8

Among the many books on Adobe Photoshop Elements are these fine titles.

the version included on this book's CD. (Make sure to disable any spyware and all antivirus software before installing Elements.) After you follow the step-by-step installation procedure, Elements is yours to use free for 30 days. In the following sections, I show you some of the most important features of Elements.

Adding Photos to the Elements Organizer

As you can see in Figure 5.9, you can import into Elements digital photos from a wide variety of devices and locations. You can bring them in directly from your camera, from a scanner attached to your computer, from various locations on your hard drive, from the Internet, and even from a camera phone.

So that you have some images with which to work in this project's exercises, follow these steps:

FIGURE 5.9

You can even scan in printed photos by using Elements—if you have a scanner, that is.

1. **Insert the book's CD**—Open the tray for your computer's optical drive and insert the CD that came with this book. Give the computer a moment or two to recognize and *mount* (make available for use) the CD.

2. **Start Elements**—If Elements is not yet running, select the program from your Start menu and let it load.

NOTE

Keep in mind that the images on this book's CD are for your use *only* with the exercises in the book. All the images are copyrighted and cannot be used for any purpose other than your personal education while using this book.

3. **Click the Import button**—Click the Import button, as shown in Figure 5.9, and select From Files and Folders.

4. **Select the Practice Files folder**—In the Get Photos from Files and Folders window that appears, navigate to the CD, select the Practice Images folder, and click the Get Photos button (see Figure 5.10).

5. **Acknowledge the reminder message**—After you click Get Photos, Elements reminds you that what you are about to see in the Organizer are the images you have just imported, not all the images in the catalog. Click the OK button (see

Figure 5.11) to acknowledge the message. (If you would like, you can check the Don't Show Again box so that you won't have to see the message again in the future.)

Creating a Stack

One of the many convenience features of the Organizer is *stacking*. Rather than viewing dozens of similar images in the preview area, you can create groups of similar images and view only the topmost of the photos as a preview. Stacking helps streamline your preview window, making it easier to find one specific image. To take advantage of stacking, follow these steps:

1. **Select photos to stack**—In the Organizer, Ctrl+click the four pictures of Nelson the dog. These photos are all very similar in nature and, rather than having them all visible in the Organizer, they are excellent candidates for a stack.

FIGURE 5.10

You can select a folder or open the folder and select specific files.

TEST DRIVING ADOBE PHOTOSHOP ELEMENTS

FIGURE 5.11

Elements lets you know that you're going to see only new photos.

http://www.flickr.com/

FLICKR

Flickr is something lots of people have started using because they offer so many features for sharing photos, organizing albums, and posting to blogs. Best of all, a basic account is free. Lots of sites offer free photo storage and sharing, but check out Flickr if you want something a little more robust. When people come to view your photos, they can leave comments and tags on the pictures. You can also create group-photo pools so that if a bunch of people have photos from the same event, everyone can upload to the same place.

TIP

See the slider to the lower right of the preview area? Drag it to the left to make the thumbnail images smaller; drag it to the right to make them larger.

2. **Create the stack**—Select Edit, Stack, Stack Selected Photos. In the Organizer, the photos now occupy only one space instead of four. As you see in Figure 5.12, the border around the photo changes to indicate a stack.

3. **Open the stack**—If you don't see a blue border around your stack, click its thumbnail. (Compare the lack of blue border

FIGURE 5.12
Stacks are indicated in the Organizer with a multi-photo frame.

around the stack in Figure 5.12 with the blue border around a single image in the upcoming Figure 5.13.) Use the menu command Edit, Stack, Reveal Photos in Stack or the keyboard shortcut Ctrl+Alt+R to show the stacked photos.

4. **Set the top image for the stack**—Decide which of the photos in the stack you like most or which one best represents the content of the stack and click it. Use the menu command Edit, Stack, Set as Top Photo. (Also notice the Remove Selected Photos from Stack command. It unstacks the stack, returning the photos to their individual status in the Organizer.)

5. **Return to the catalog**—Click the Back to All Photos button (see Figure 5.13) to restack the stack, with your designated photo on top.

TIP

You can access a *context menu* in Elements by right-clicking a photo in the Organizer. You can use the context menu to assign ranks to individual photos (from one to five stars), add captions, add to and remove from collections, hide photos, and add photos to your Favorites set.

6. **Explore the thumbnail size and click Photo Review**—At the bottom of the Organizer window, drag the thumbnail size slider (shown earlier, in the Tip following step 1) back and forth to see how you can vary the size of the preview images. To the left of the slider, click the Photo Review button to explore the images in a musical slideshow (see Figure 5.14). Press the Esc key when you're finished viewing a presentation.

FIGURE 5.13

After designating your top image, you can return to the catalog by clicking the Back to All Photos button.

FIGURE 5.14

The thumbnail size slider adjusts preview size, while the Photo Review button sends you into a slideshow mode—with music!

Improving an Image with Quick Fix

The Quick Fix option in Elements lets you handle most of the basic image correction jobs in a snap. Follow these steps to give it a spin:

1. **Open REDEYE.JPG in Quick Fix**—In the Organizer, go to the Find menu and select By Filename or use the keyboard shortcut Ctrl+Shift+K. Enter **REDEYE** and click the Find button. When the search result appears (just the one photo named **REDEYE.JPG**), click the image. In the upper button bar, click the Edit button and select Go to Quick Fix (see Figure 5.15). Wait patiently while the Editor loads for the first time. Select Before and After from the drop-down menu below the preview area (also shown in Figure 5.15). This enables you to compare the corrections you're making to the original image.

2. **Adjust color and lighting with one click**—To the right, click the Auto button next to Smart Fix (see Figure 5.16). Elements analyzes the image and decides how it thinks the colors and lighting in the image should look; it then applies those adjustments. Unless the image is in *really* bad shape, the improvements are generally subtle.

3. **Undo the Auto repair**—To compare Smart Fix's changes to what you can do yourself, click the Reset button (see Figure 5.17) and then drag the sliders to improve the lighting and color to your taste.

4. **Zoom in on the red eyes**—To the far left, select the Zoom tool and drag a rectangle around the eyes in the After image, as shown in Figure 5.18.

5. **Fix the Red Eye**—Select the Red Eye Removal tool and drag a small rectangle around each of the eyes (as shown in

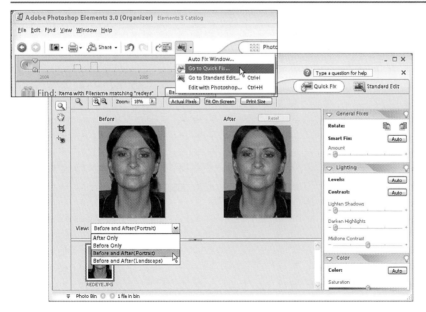

FIGURE 5.15

Above, you see the Go to Quick Fix command in the Organizer. Below, you see the Before and After (Portrait) option in the Editor.

FIGURE 5.16

Note that there are also individual Auto buttons for Levels, Contrast, and Color.

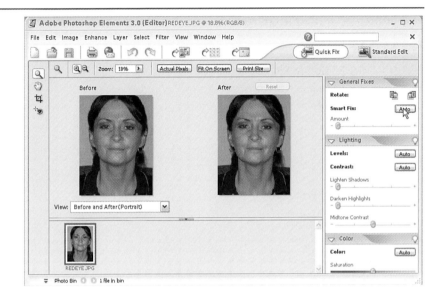

FIGURE 5.17

Elements lets you control the lighting and color personally. The Reset button is shown to the upper left.

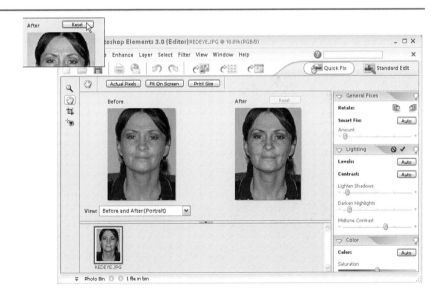

Figure 5.19). Note that, unlike Picasa, Elements has sliders above the preview area that enable you to control the amount of red eye correction. As you can see, the default values of 50% and 50% do a much better job than Picasa's Redeye button (which you used with this same photo in Project 3).

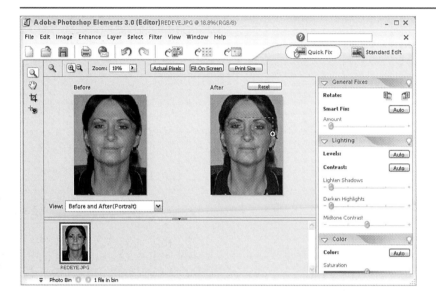

FIGURE 5.18

You could use the Zoom slider and then reposition the image within the window with the Hand tool, but using the Zoom tool is faster.

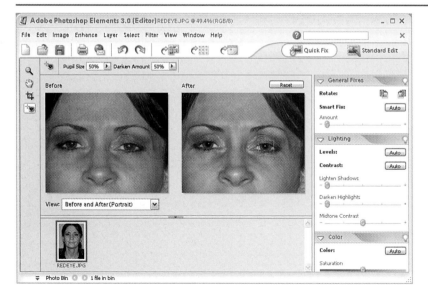

FIGURE 5.19

You can use the Pupil Size and Darken Amount sliders to fine-tune your repair.

> **NOTE**
>
> Don't close this image yet—you'll continue to use it in the next exercise!

Touching Up an Image

Let's continue on with repairs to **REDEYE.JPG**. If the image isn't open, reopen it from the Organizer and then follow these steps:

1. **Go to Standard Edit mode**—In the upper-right of the Elements window, click the Standard Edit button to jump to the powerful side of Elements. In Standard Edit mode, you use tools found in the full version of Photoshop to *really* control the appearance of your image.

> **TIP**
>
> When working in Standard Edit mode, maximizing your Elements window is usually a good idea. To maximize the window, in the upper-right corner of the window, click the button just to the left of the black X. When Elements is maximized, you have more room to work.

PHOTO COMPOSITION ARTICLES

This site is a wonderful resource for learning how to create a picture. No matter what kind of camera you have, taking attractive photos takes skill in composition and direction in art. This great little site tells you how to use the "Rule of Thirds" to create the perfect photo, follow color rules, and frame your picture while shooting. Some of the tips are pretty simple once you read them, but not always obvious to the beginning photographer. You'll be amazed by how much you learn from this site.

2. **Use the Spot Healing brush**—In the toolbox to the left of the image preview, select the Spot Healing brush (shown selected in Figure 5.20). Using the Spot Healing brush, paint over the areas indicated in Figure 5.20, one at a time. Watch the blemishes vanish like magic!

FIGURE 5.20

You should drag small circles in a limited area to use the Spot Healing brush effectively.

3. **Use the regular Healing brush**—In the Elements toolbox, click the Spot Healing brush and hold the mouse button down until the small menu shown to the lower left in Figure 5.21 appears. Select the Healing brush (as shown). To use the Healing brush, you Alt+click in an area of smooth skin and then release the Alt button and drag the cursor over an area you want to smooth. The three frames at the top of Figure 5.21 demonstrate the process of Alt+clicking, dragging, and the result. To the lower right in Figure 5.21, you see the result (on the left half of the face) of a few minutes' work with the Healing brush.

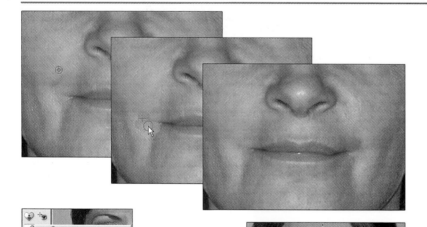

FIGURE 5.21

Like the Spot Healing brush, the Healing brush can smooth texture.

113

TEST DRIVING ADOBE PHOTOSHOP ELEMENTS

NOTE

This exercise and that which follows barely scratch the surface of what you can do in Photoshop Elements. In the upper-right portion of the Elements window is the How To tab. Feel free to browse through those topics at your leisure and experiment with images of your own.

4. **Close REDEYE.JPG**—You can now close **REDEYE.JPG**. Simply click the black X in the upper right of the image window, as shown in Figure 5.22. Remember that you want to close the **REDEYE.JPG** window, not the Elements window itself. (There's no need to save your work.) Elements automatically returns to the Organizer's Find window, showing the results of your search for "REDEYE."

FIGURE 5.22
You click the black X to close the image window.

5. **Open LAMPHEAD.JPG**—Select Find, By Filename again. This time search for **LAMPHEAD**. With the one result showing in the Find window selected, click the Edit button and then select Go to Standard Edit (see Figure 5.23).

FIGURE 5.23
You should open LAMPHEAD.JPG in the Elements Standard Edit mode.

6. **Zoom in and select the Clone Stamp tool**—Use the Zoom tool to close in on the upper-right portion of the image, and then switch to the Clone Stamp tool, as shown in Figure 5.24.

7. **Clone away the lamppost**—As with the Healing brush, with the Clone Stamp tool, you designate a source area by Alt+clicking, and then you drag through an area of the image. Whereas the Healing brush replaces the texture of an area, the Clone

Stamp tool actually replaces the pixels—much like a copy/paste using a brush.

Alt+click a short distance to the left of the lamppost (as shown to the left in Figure 5.25) and then move the cursor to the top of the lamppost. Press and hold down the mouse button and drag over the area to make the lamppost disappear completely.

When you've finished experimenting with the Clone Stamp tool, you can close the image **LAMPHEAD.JPG**, again without saving your changes.

FIGURE 5.24

You can drag the Zoom tool to get a better view and then switch to the Clone Stamp tool.

FIGURE 5.25

The Clone Stamp tool can remedy many image composition problems.

NOTE

Remember back in Project 1, "Capture Your Life Visually," where we discuss image composition? The photo used in the preceding exercise is an excellent example of *why* you should be aware of the interaction between the subject and the background. Thankfully, the Clone Stamp tool can often come to the rescue!

If you would like to experiment more with the Clone Stamp tool, Alt+click on the top of the Eiffel Tower to set that as the *source point* (the "from" that you're copying), move the cursor a little to the right, and then drag the tool to create a second landmark. Keep an eye on both the crosshair that indicates the source area and the cursor as you paint.

Combining Photos: The Basic Collage

In this next pair of exercises, we'll take a look at how easy it is to combine a couple different photos and some text to create a custom post-card. In the following steps you'll see a great tool for making selections, the power of layers, and even get a look at layer styles and filters:

1. **Open the work images**—In the Elements Organizer window, click the image **HAPPYCAMPER.JPG** (the woman in the blue hat and sunglasses in front of a grassy slope), then Ctrl+click **CRESTED-BUTTE02.JPG** (the solitary mountain). As shown in Figure 5.26, you can see that both images are selected because they are surrounded by blue borders. Click the Edit button and then select Go to Standard Edit.

FIGURE 5.26

You Ctrl+click to select multiple images in the Organizer.

EPHOTOZINE

What better way to learn how to compose photos and edit them than a place where there's an entire gallery of photos just begging to be modified? This site has a lot of fun stuff on it, including a reader's gallery, an online printing resource, and an editor's choice section. The greatest part is the Modifiable Photo Gallery. It contains 782 pages of striking, strange, and beautiful photos that people have uploaded for everyone to play with and improve. The photographer even includes information about the brand and model of camera that was used, as well as info on what special lenses and attachments were used to produce an effect.

2. **Set up the Selection brush**—In order to copy the happy camper to the mountain image, you must first identify what part of the image to copy. If necessary, click the title bar of the **HAPPYCAMPER.JPG** window to bring it to the front. In the toolbox, click the Selection brush (see Figure 5.27). In the Options bar, which runs above the work area, change Size to 75 px and Hardness to 80%.

3. **Paint to make a selection**—Click the mouse button, hold it down, and paint over most of the happy camper, including the hat and jacket. As you paint, you see a dotted line appear to show you what has been included in the selection (see Figure 5.28). Try to be careful along edges, but don't worry about excluding little bits of the subject or including a bit of the background—you'll fix those areas in the next step.

TIP

If you need to take a little break while painting with the Selection brush, it's not a problem. Release the mouse button and then, when you're ready, press the mouse button and start painting again.

4. **Touch up the selection**—When you have the basic selection made, zoom in and work with a smaller brush, perhaps 20 pixels (make the change in the Options bar). Click and drag to add to the selection, Alt+drag to subtract areas of the background from the selection (see Figure 5.29).

FIGURE 5.27

The Options bar, along the top of the work area, changes with the selected tool.

FIGURE 5.28

The dotted line shows what's being painted into the selection.

FIGURE 5.29

Alt+dragging the Selection brush removes areas of the background from the selection.

TIP

While you're working zoomed-in, press and hold down the Spacebar to temporarily switch to the Hand tool. You can then click the mouse button and drag to reposition the image within the window. Release the mouse button before releasing the Spacebar.

5. **Copy the selection to a new layer**—When you're happy with your selection, press the keyboard shortcut Ctrl+J to copy the selected camper to a separate layer. The checkerboard pattern you see in the background for Layer 1 in Figure 5.30 indicates transparent pixels. (The Layers palette is generally found in the lower-right corner of the Elements workspace. You can, however, as I did in Figure 5.30, drag any palette's tab wherever you want it.)

FIGURE 5.30

The Layers palette shows two layers: the original image ("Background") and the camper, isolated with a selection and copied to a new layer (Layer 1) .

NOTE

If you don't want to take the time to finish working with the Selection brush, you can use the File, Open command to open HAPPYCAMPER-extract.PNG and continue with this exercise.

6. **Copy Layer 1 to the second image**—Position your two image windows so that you can see both (at least partially). In the Layers palette, click directly on the name "Layer 1" and, holding down the mouse button, drag the layer to the window of the file **CRESTEDBUTTE02.JPG** (see Figure 5.31). This copies the content of the layer from one image to another.

NOTE

You can now close HAPPYCAMPER.JPG. If you would like to save your work, use the File, Save As command. In order to retain the layer you created, you have to save the file in Photoshop's PSD format, the TIFF format, or the Photoshop PDF format. These are the only file formats that can have multiple layers.

FIGURE 5.31

Dragging a layer from the Layers palette to another image's window copies the layer content.

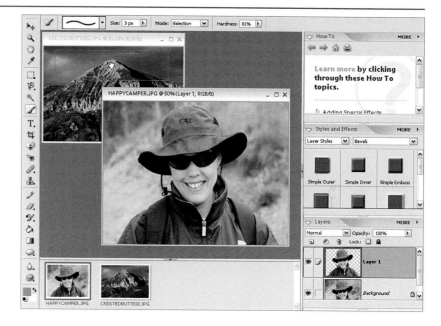

7. **Position the camper in front of the mountain**—For the rest of this exercise and the next, you'll work only in the file named **CRESTEDBUTTE02.JPG**. In the Elements toolbox, select the Move tool, the very first tool in the upper left (or at the very top, if your toolbox is showing a single column rather than two columns of tools). Drag the camper layer in the image window until it's aligned with the bottom of the image and centered horizontally (see Figure 5.32) .

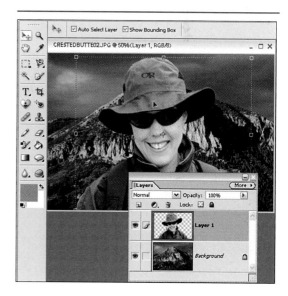

FIGURE 5.32

You use the Move tool to position Layer 1.

NOTE

Notice that the image below, the mountain on the lower layer, becomes visible behind the camper as you move that layer. The two layers exist independently of each other, with the upper layer hiding (not destroying or replacing) the lower layer. Now *that's* a powerful creative feature!

8. **Resize the camper**—Notice that the content of Layer 1, the extracted camper, is surrounded by a bounding box, with the standard anchor points in the corners and middle of each edge. Shift+click the upper-right anchor point and drag toward the lower-left until the camper no longer hides the mountain, as shown in Figure 5.33. Press Enter when you're done.

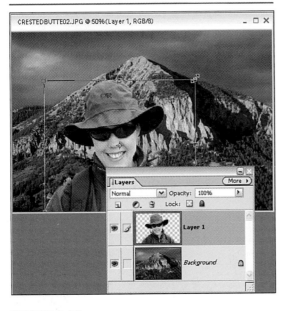

FIGURE 5.33

Resize the content of the selected layer by dragging the bounding box. Using the Shift key prevents distortion of the width-to-height relationship of the image.

9. **Save your work**—Select File, Save As, navigate to the My Pictures folder on your hard drive (don't attempt to save to the book's CD), and save the file in Photoshop's PSD format as **CAMPERPOSTCARD.PSD**. Don't close the file—you'll continue to use it in the next exercise.

FIGURE 5.34

You can select Photoshop (*.PSD;*.PDD) as the file format in the Format drop-down menu.

Working with the Type Tool and Layer Styles

By working with Photoshop Elements, you can add text to your images. I don't mean just adding a caption below a photo; I mean adding the text *as artwork* in your images. This exercise is a simple demonstration of using the Type tool, with a quick look at the Layer Styles feature and filters in Elements:

1. **Select the Type tool and set the options**—In the toolbox, choose the Type tool (see Figure 5.35) and in the Options bar, choose Times New Roman as the font, 12 pt as the font size, and Centered for alignment (near the right end of the Options bar).

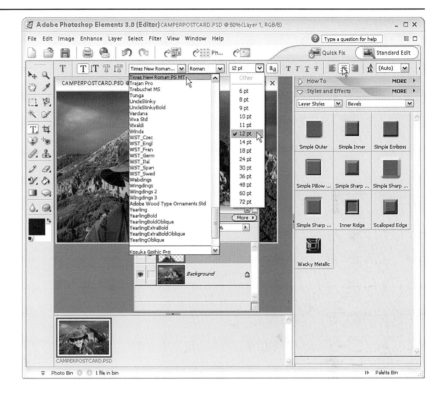

2. **Add the first line of type**—Press D on the keyboard to set your foreground color to black and your background color to white. (The color swatches are at the bottom of the toolbox.) Position the I-beam cursor in your image, directly over the peak of the mountain, and type the words "**Greetings from**" (as shown in Figure 5.36).

3. **Add the second line of type**—Press the Enter key. Move the mouse into the Options bar and change the font size from 12 pt to 24 pt. Type the words "**Mt. Crested Butte**" (see Figure 5.37) and then use the keyboard shortcut Ctrl+Enter to accept the text. (Note in Figure 5.37 that the text is on a separate layer: It hides the photo of the mountain below, but that image is still 100% complete. You could

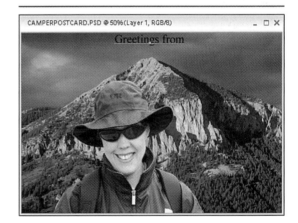

FIGURE 5.36

You can type directly in an image in Elements.

http://www.goodretouching.com

GOOD RETOUCHING

What if you want a really professional-looking picture but you're not quite an expert yet with editing software? There are retouching services on the Web that will charge you nominal fees to retouch your photos. They will do some of the more complex things such as taking objects or people out of your picture; enhancing the color; removing blemishes or wrinkles; and opening closed eyes in pictures. Check out this site's cool before-and-after pictures.

use the Move tool to reposition the type layer just as you moved the camper layer earlier.)

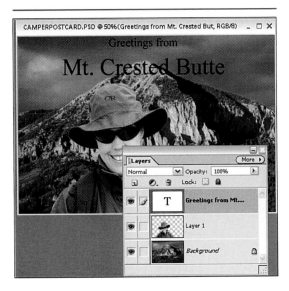

FIGURE 5.37
You can have different sizes of type in one type layer.

4. **Add a layer style**—With the type layer active in the Layers palette (that is, with it highlighted), try various styles from the Styles and Effects palette (see Figure 5.38 for some examples).

NOTE

Styles can be applied to any layer not named "Background." (Background layers cannot have transparent areas. You rename a Background layer in the Layers palette to convert it to a regular layer.) You could, for example, apply a small Bevel effect to Layer 1 to visually separate the camper from the mountain image.

FIGURE 5.38

These are just a few of the styles available in the Styles and Effects palette.

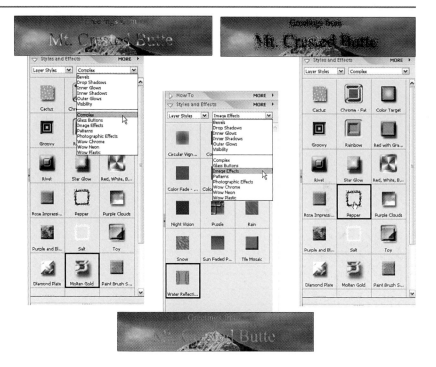

5. **Scale a style**—As you may have noticed while experimenting, some of the styles are designed for selections and text much larger than that with which you are working. In the Patterns section of the Styles and Effects palette, choose the Brick Wall style by clicking it. Next, select Layer, Layer Style and then choose Scale Effects. In the Scale Layer Effects dialog box, enter **10** and click OK. As you see in Figure 5.39, scaling the Brick Wall style produces a very nice effect on this text.

6. **Experiment with filters**—In the Layers palette, click Layer 1 to make the camper layer active. In the Styles and Effects palette, click the left-hand drop-down menu (which says Layer Styles) and select Filters. Double-click the Angled Strokes filter to open the oversized Filter window.

Click in the preview area (if necessary) and drag the preview so that you can better view it. Try settings of Direction Balance: 60, Stroke Length: 6, and Sharpness: 6 (see Figure 5.40).

Take some time to experiment with other filters while you're in the filter window. Here are some suggestions (with results shown in Figure 5.41):

▶ In the Artistic section (click the triangle to the left of Artistic in the center column), try the Cutout filter with settings of Number of Levels: 7, Edge Simplicity: 6, and Edge Fidelity: 3.

▶ In the Distort section, try the Diffuse Glow filter with settings of Graininess: 0, Glow Amount: 15, and Clear Amount: 20.

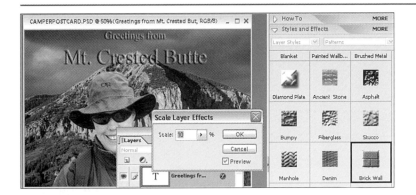

FIGURE 5.39

If a style looks lousy, you can try scaling the effects down (or up) to better suit the content of your artwork.

FIGURE 5.40

The appropriate settings generally depend on the size of the image and the image content.

TIP

You can switch among filters by using the drop-down menu directly below the Help button.

- In the Sketch section, try the Graphic Pen filter with settings of Stroke Length: 12, Light/Dark Balance: 15, and Stroke Direction: Left Diagonal.

- In the Texture section, try the Stained Glass filter with settings of Cell Size: 2, Border Thickness: 1, and Light Intensity: 1.

If you want powerful control over your images—or if you enjoyed getting creative with the filters and styles—then Elements is likely a very good investment.

FIGURE 5.41

Top-left: Cutout, top-right: Diffuse Glow, bottom-left: Graphic Pen, and bottom-right: Stained Glass.

TIP

You can apply more than one filter at the same time. To do so, you select a filter, click the New Effect Layer button to the left of the Trash icon in the lower right, and then select another filter. You could, for example, apply the Artistic, Paint Daubs filter (Brush Size: 6, Sharpness: 24, Brush Type: Simple), click the New Effect Layer button, and apply Texture, Texturizer (Scaling: 110%, Relief: 8, Light: Top Left) to create a painterly effect.

Closing Thoughts

I hope you've enjoyed reading this book as much as I've enjoyed putting it together. It's been a real treat to be able to share some of my experience with you. Hopefully you've found it both educational and entertaining.

One word of caution: Once you get started with digital photography and advanced image manipulation, it's *tough* to stop. But who knows where your road will lead? Maybe you'll take what you've learned here and turn your photography into wonderful works of art and creative projects, suitable for hanging and giving as gifts. Maybe someday this hobby could even become a profitable sideline.

Thanks for making it this far!

Index

CREATE YOUR OWN DIGITAL PHOTOGRAPHY

U – V – W

Easy Projects Readers Can Create on Their Own

With the ever-increasing popularity of the World Wide Web, more and more individuals are creating their first websites. Many more would like to, but are either unaware of how to get started, or feel that they do not possess the computer expertise required to accomplish such a feat. ***Create Your Own Website: 5 Easy Templates, Second Edition*** (ISBN: 0-672-32826-7), show these individuals that creating a website is both easy and fun. This book examines creating different types of websites, including: blogs, eBay StoreFronts, image sharing and family websites.

Create Your Own Digital Movies (ISBN: 0-672-32834-8) walks a reader through choosing a camera, filming dos and don'ts, as well as creating, editing, saving and sharing movies. Readers will learn five projects that every digital video camera owner should know and benefit from numerous tricks, tips, and other cool information like how to acquire good footage, and how to save and share final movies. The CD includes software add-ons to Microsoft MovieMaker 2, including extra sound effects, music, titles, cut scenes, and transitions.

Create Your Own Digital Photography (ISBN: 0-672-32830-5) is unique in its approach in that it doesn't get bogged down in the intricacies of camera mechanics or software use. Instead it takes readers through choosing a camera, photography dos and don'ts, scanning tips, printing and resolution constraints, image alterations, and file storage ideas. Readers will learn five projects that every digital camera owner should know and benefit from numerous tricks, tips, and other cool information like how to publish photobooks, order prints online, how to get the right resolution for an 8x10 print, remove red eye, and more. Included is a CD that features Picasa 2.

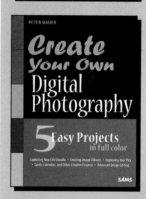

Create Your Own Home Networks (ISBN: 0-672-32832-1) is a unique book that will show you how to make your home computers talk to each other while sharing files, music and printers. The most common networking tasks are presented in project format and don't require any in-depth understanding of computer systems or networks beyond that of a typical computer user. You will learn how to set up your computers to

- Share printers, files, and Internet connections
- IM one another instantly
- Get your email in and out of your network
- Create a network jukebox
- Roam your house with wireless

What's on the CD-ROM

The companion CD-ROM contains select graphics files to follow along in the book, Adobe Photoshop Elements 3 Trial Edition, and Picasa 2.

Windows Installation Instructions

1. Insert the CD-ROM disc into your CD-ROM drive.

2. From the Windows desktop, double-click on the My Computer icon.

3. Double-click on the icon representing your CD-ROM drive.

4. Double-click start.exe and follow the on-screen instructions.

NOTE

If your version of Windows is set to hide known extensions, you may only see **start** instead of **start.exe**.

If you have the **AutoPlay** feature enabled, **start.exe** will be launched automatically whenever you insert the disc into your CD-ROM drive.

License Agreement

By opening this package, you are also agreeing to be bound by the following agreement:

You may not copy or redistribute the entire CD-ROM as a whole. Copying and redistribution of individual software programs on the CD-ROM is governed by terms set by individual copyright holders.

The installer and code from the author(s) are copyrighted by the publisher and the author(s). Individual programs and other items on the CD-ROM are copyrighted or are under an Open Source license by their various authors or other copyright holders.

This software is sold as-is without warranty of any kind, either expressed or implied, including but not limited to the implied warranties of merchantability and fitness for a particular purpose. Neither the publisher nor its dealers or distributors assumes any liability for any alleged or actual damages arising from the use of this program. (Some states do not allow for the exclusion of implied warranties, so the exclusion may not apply to you.)